# Memories of Sand:
# Excerpts of Computer Thought Photography

Created by Teer

T.M.

# Memories of Sand:
# Excerpts of Computer Thought Photography

Created by Teer

Published by HappyDeath Press 2013　Copyright © Robert Teer, 1997 All rights reserved
ISBN: 978-1-304-04455-6　Printed in the United States of America

# Memories of Sand:
# Excerpts of Computer Thought Photography

The images in this book were created in the realm of the unseen. These are "photos" from the void that mostly goes unnoticed, the space between computer generated lines.

During the fall of 1997 while using a tablet and a Macintosh Quadra I waxed about what was happening in this dance of bitmapped lines. When painting with oils and charcoal I am always fascinated by the texture and mini compositions that happen between the strokes of a brush. As the brush rides across the canvas a universe is created in its "wake". A professor once told me that every inch of a painting has to be alive. If one were to cut a painting into one-inch squares each inch would become a new separate work of art. His words have stayed with me and I always look to find compositions that "happen". Light and shadow dancing with thin and thick, layers of color melt over texture of canvas creating mountain ranges of form in the
macro world.

So what of the cyber world of art? What happens in the cracks of the texture of a raster-based image? Is there a silicone similarity to physical paint and charcoal?

I created several drawings, first black and white then black white and red. I experimented with ways to magnify and stabilize and magnify again. In time I could tell what lines and textures would yielded the most interesting results. What seemed to be pixilated chaos smoothed out and appeared organic. Forms with weight displayed themselves in these seemingly flat and geometric spaces. As if looking under a microscope I was fascinated by what I discovered.

A friend versed in computer science explained what I had stumbled upon; some form of glitch in the raster-based image in the 8-bit color Super Video Graphics Array . I did not see it as a glitch. I feel these images are not only created on computer, but are created in collaboration with a computer. The computer was trying to display what was not there, to extrapolate on the data I provided and in doing such "created" what these unseen spaces should look like. Perhaps they are memories once held in sand.

I viewed thousands of square inches of alien terrine and documented several hundred images. Sadly the images in this book are the only images that remain do to corrupt files. After revisiting this work and discovering the loss I wanted to preserve what was left. I hope they find you well.

-Teer

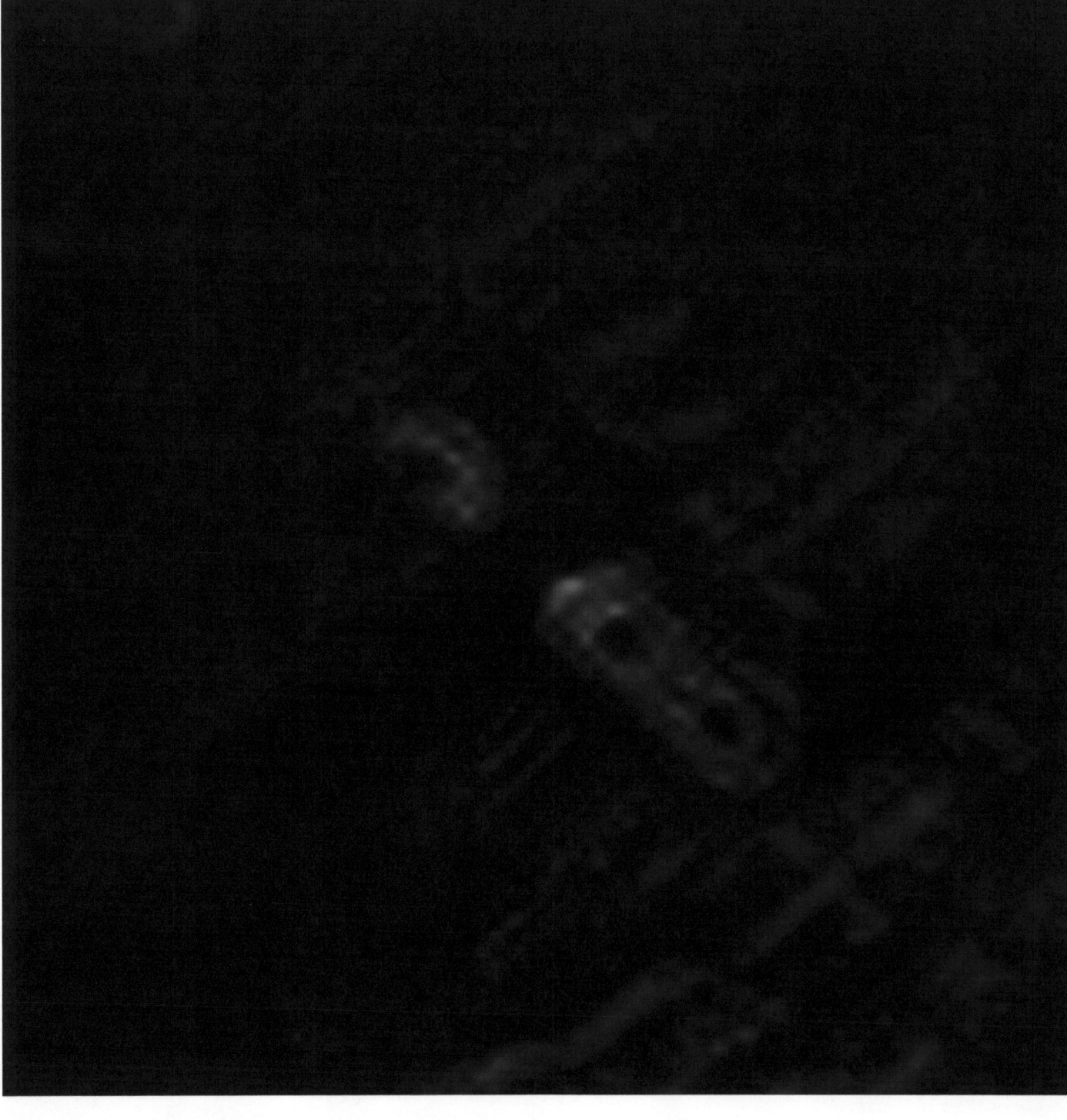

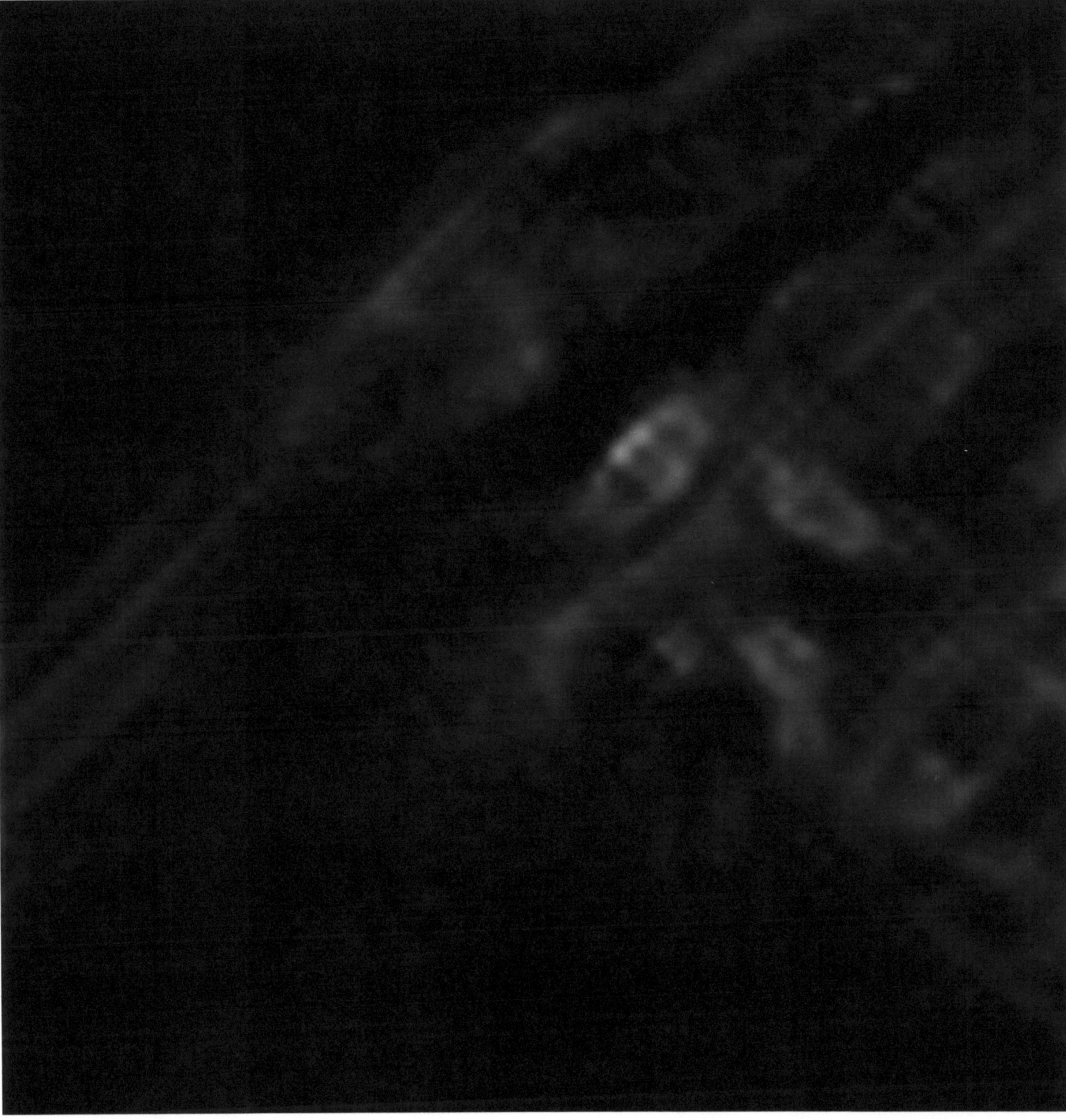

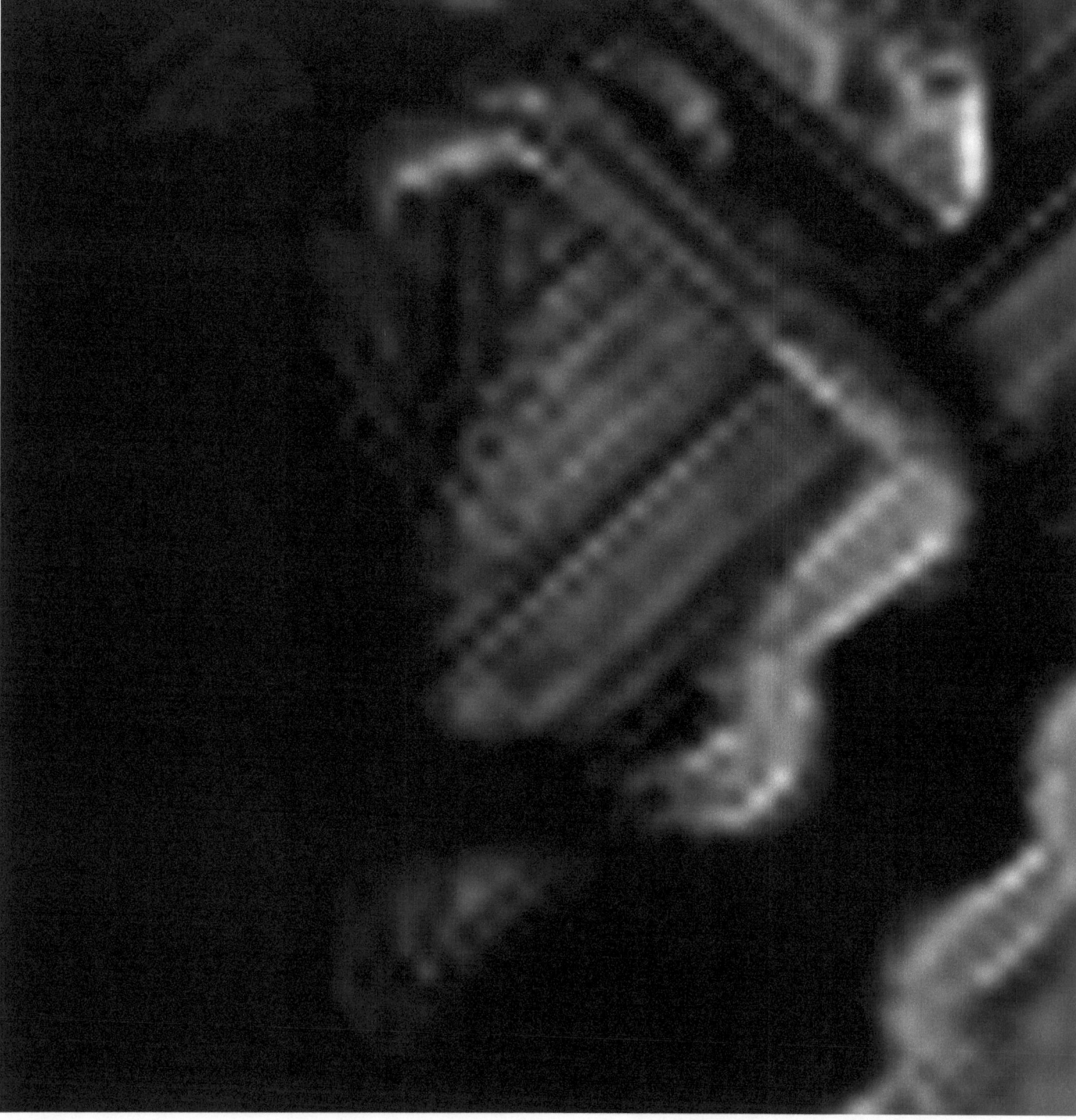

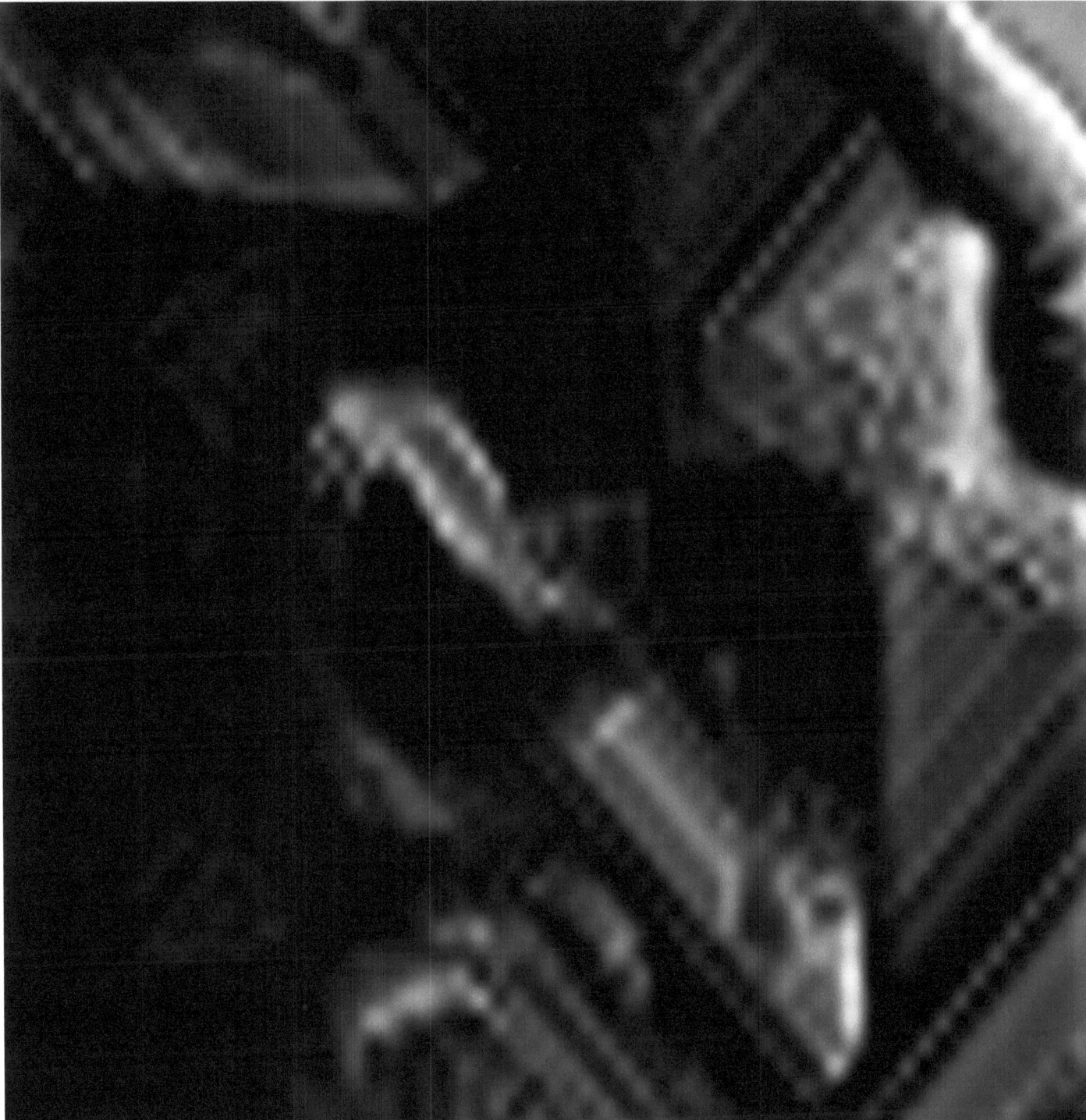

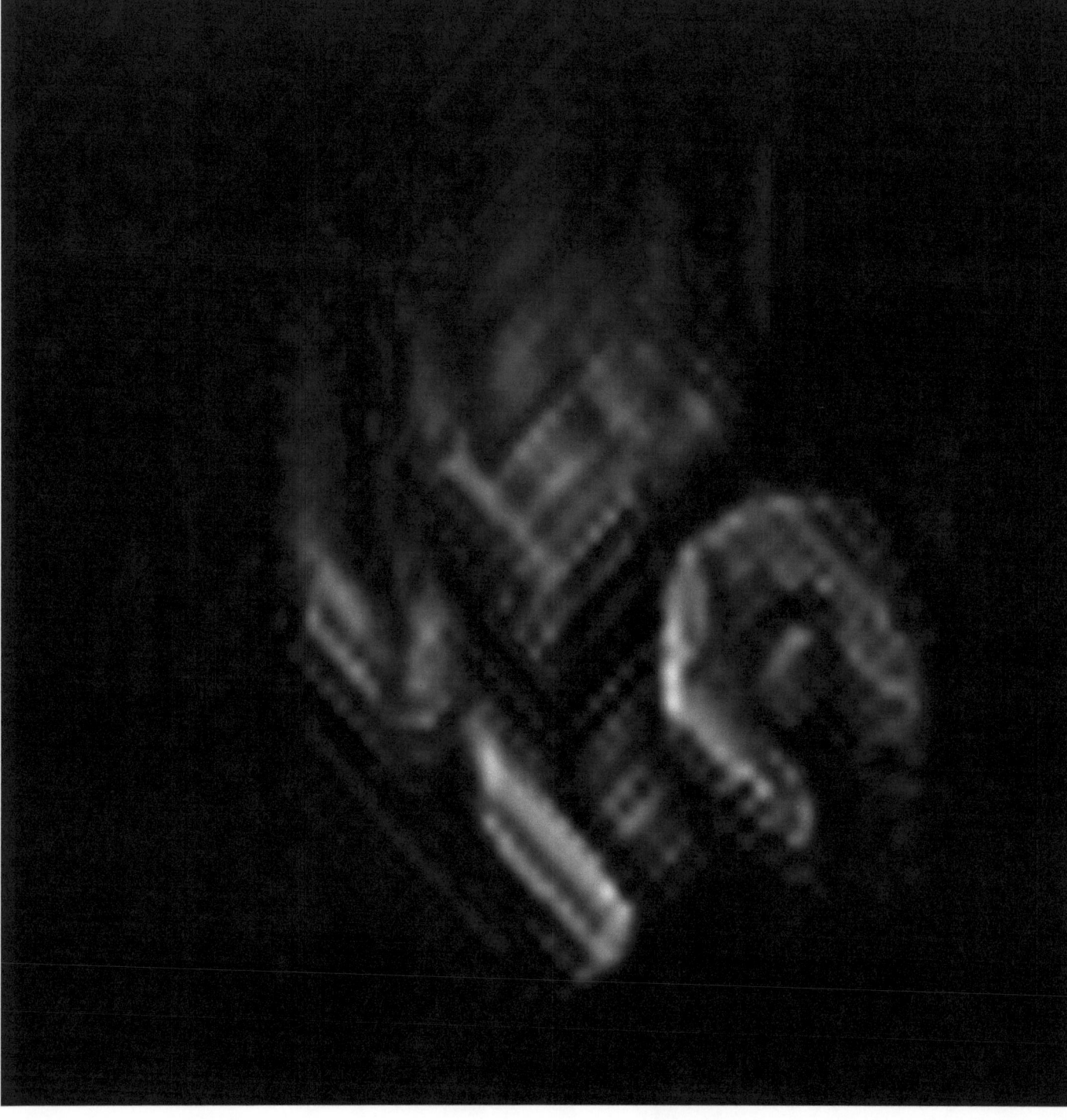

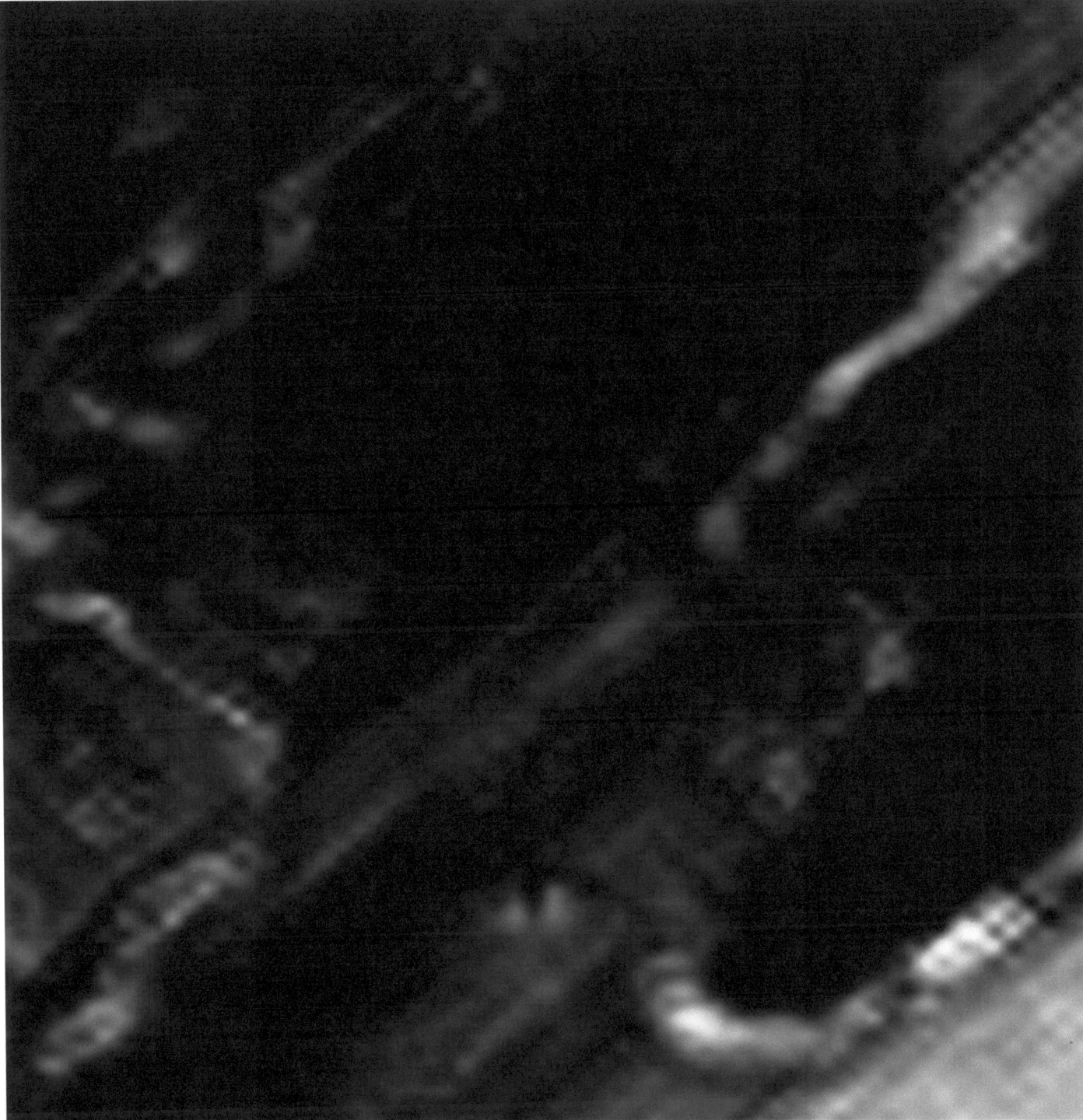

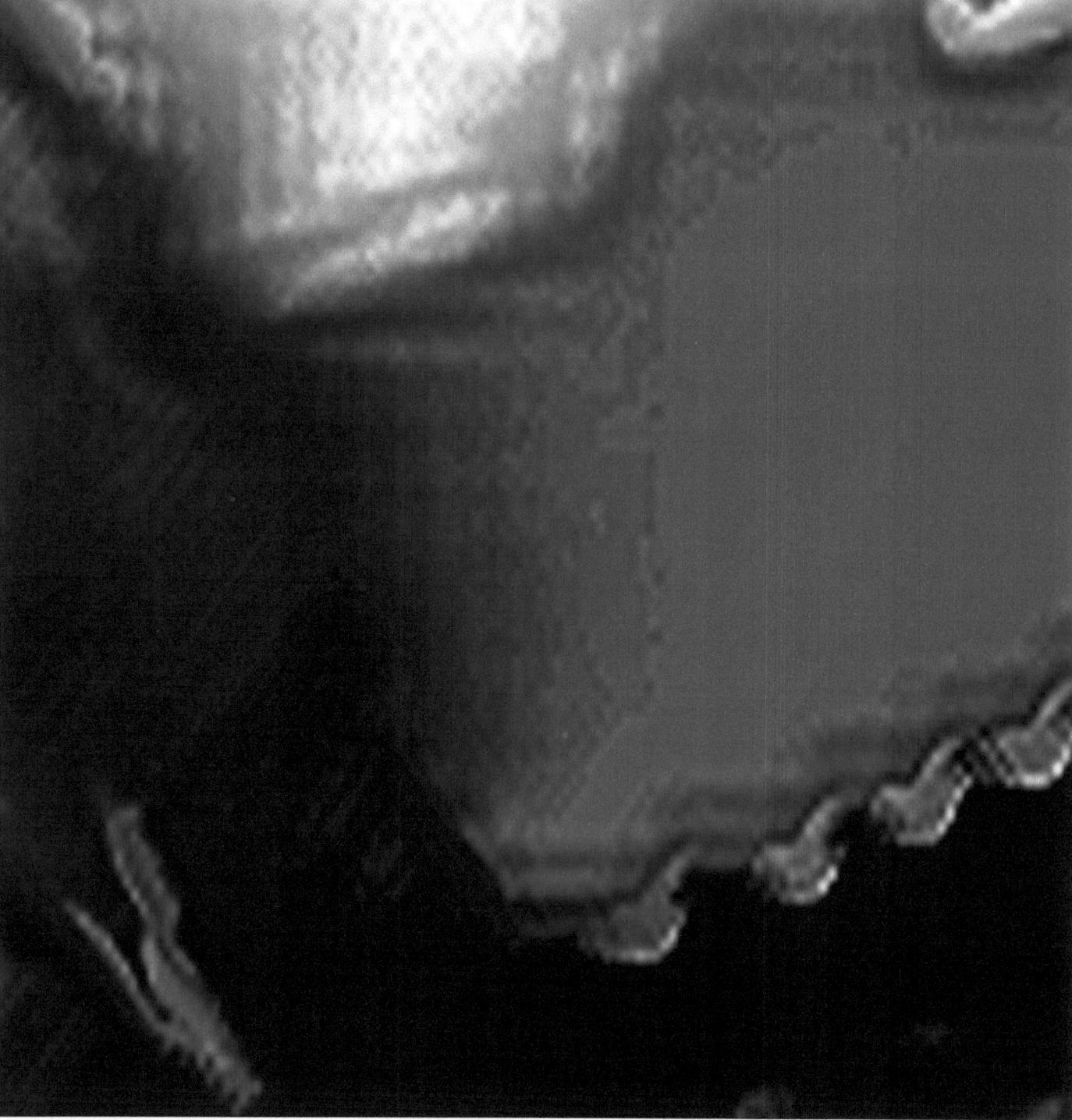

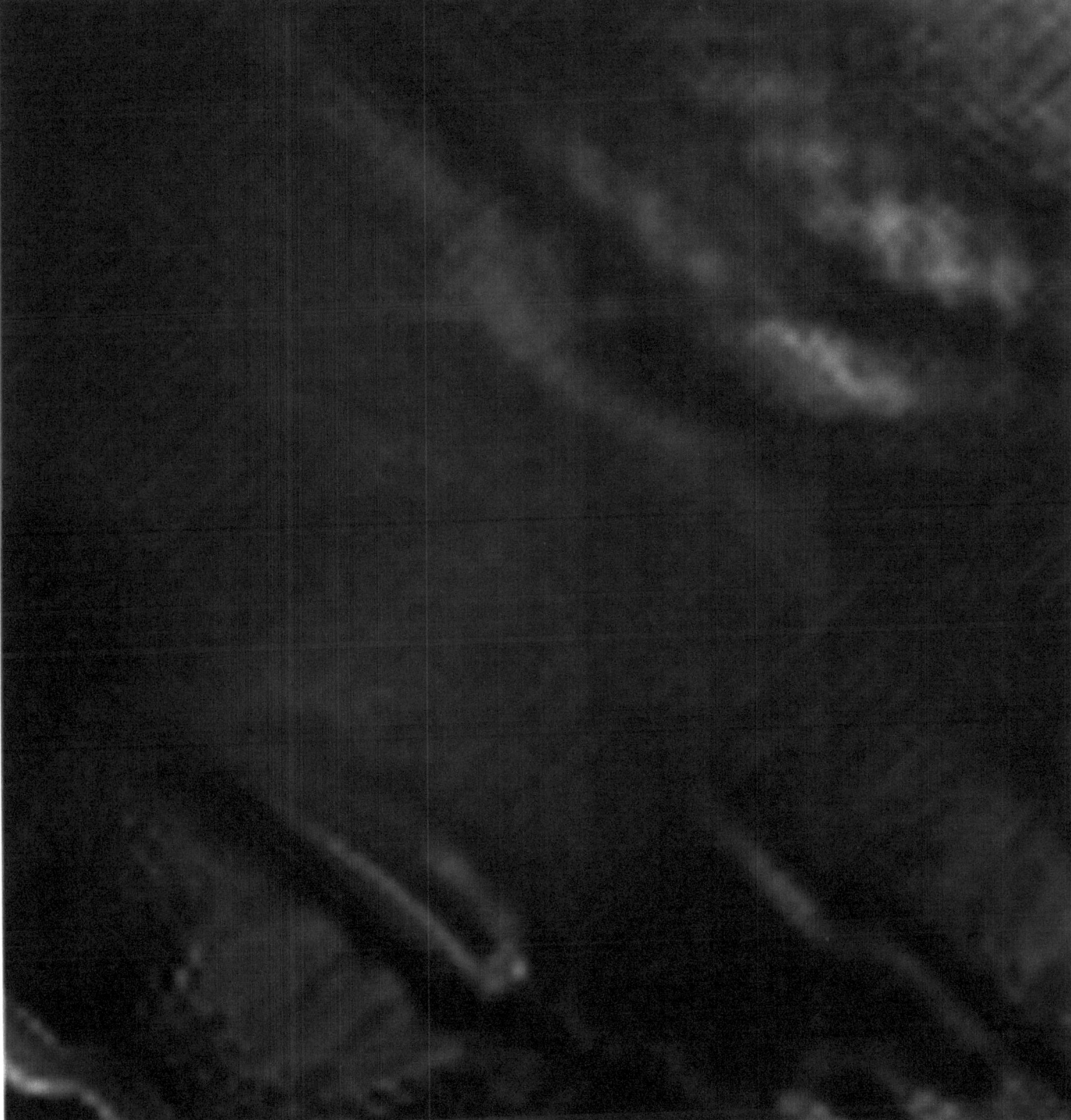

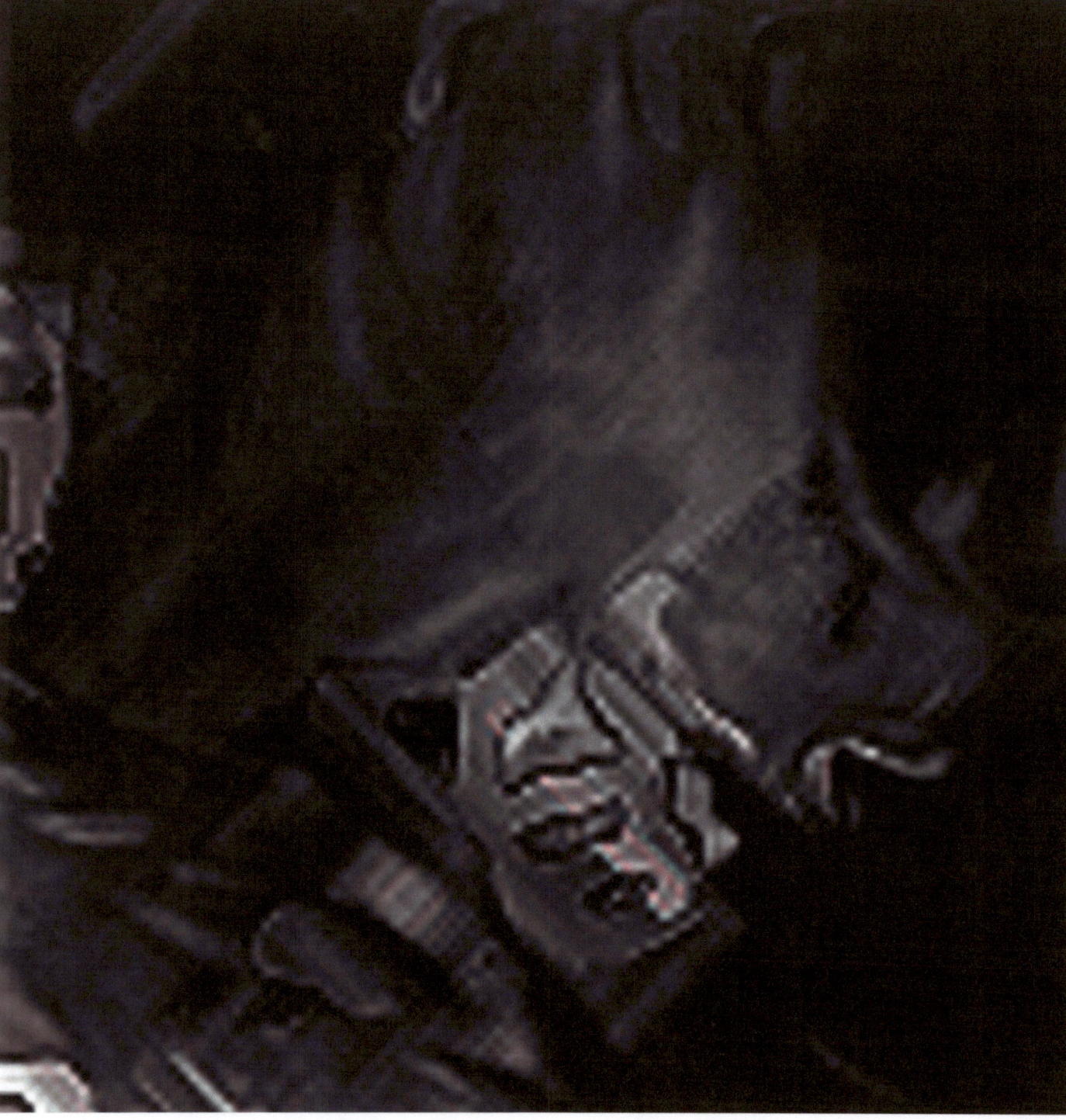

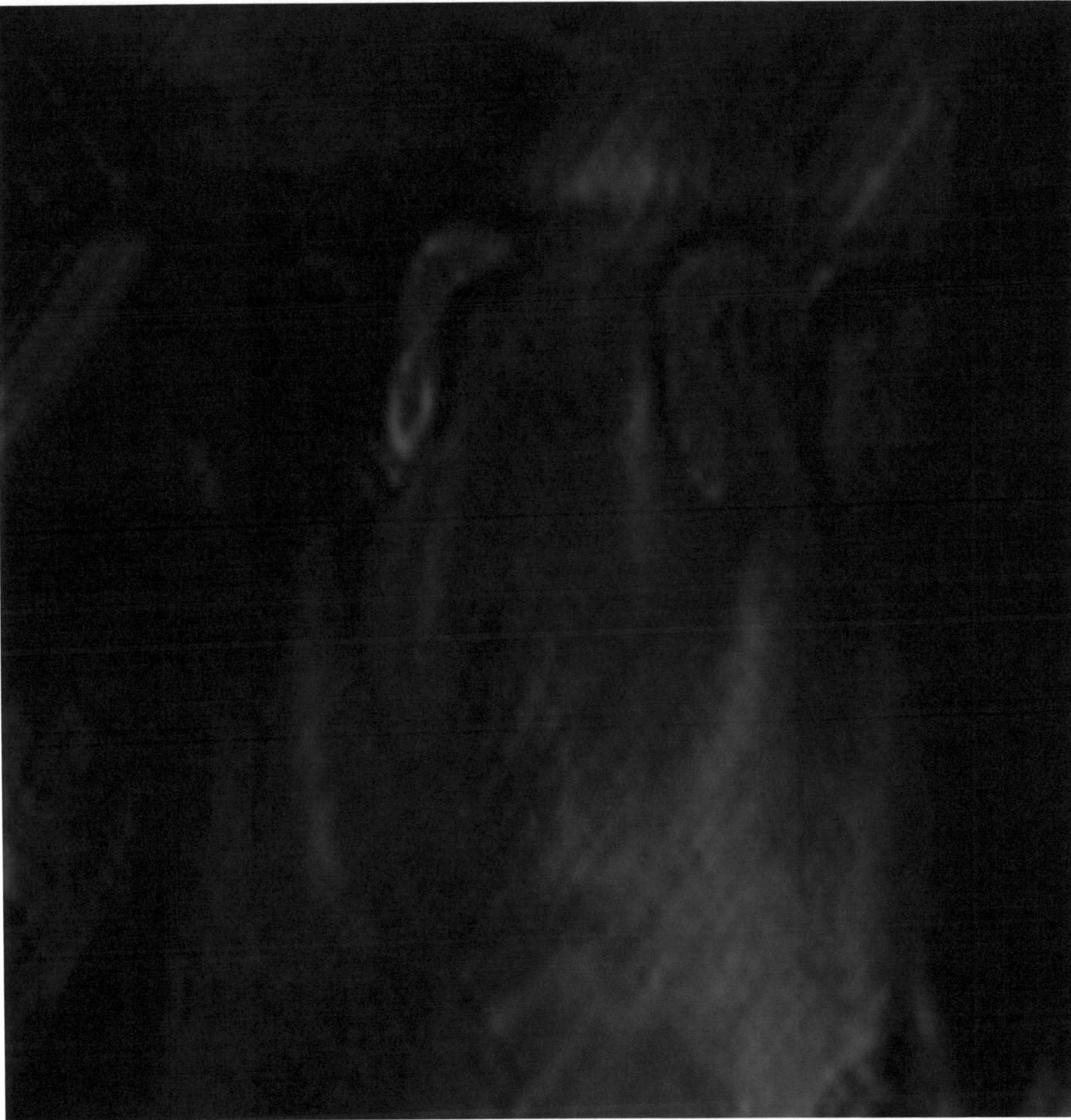

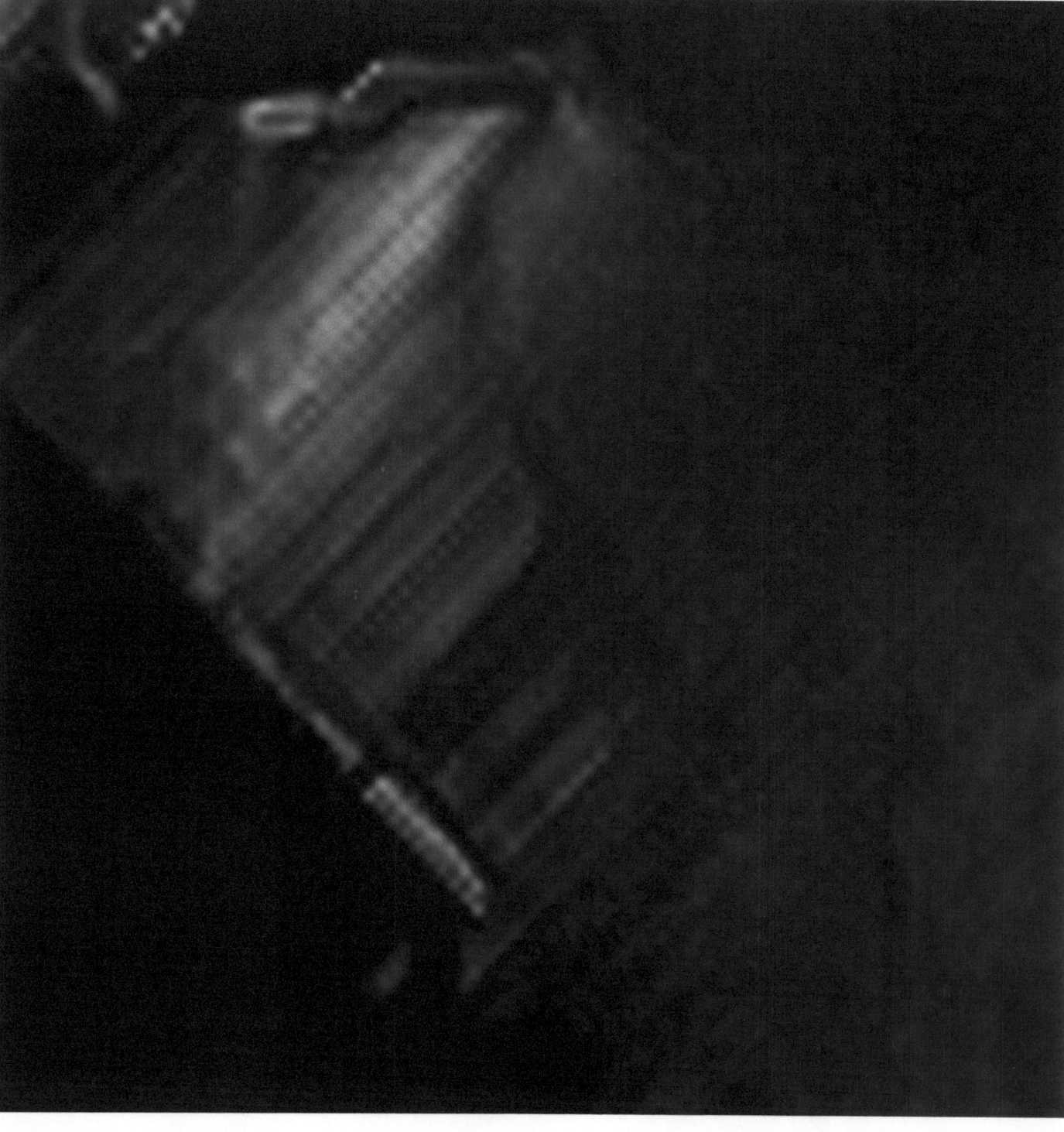

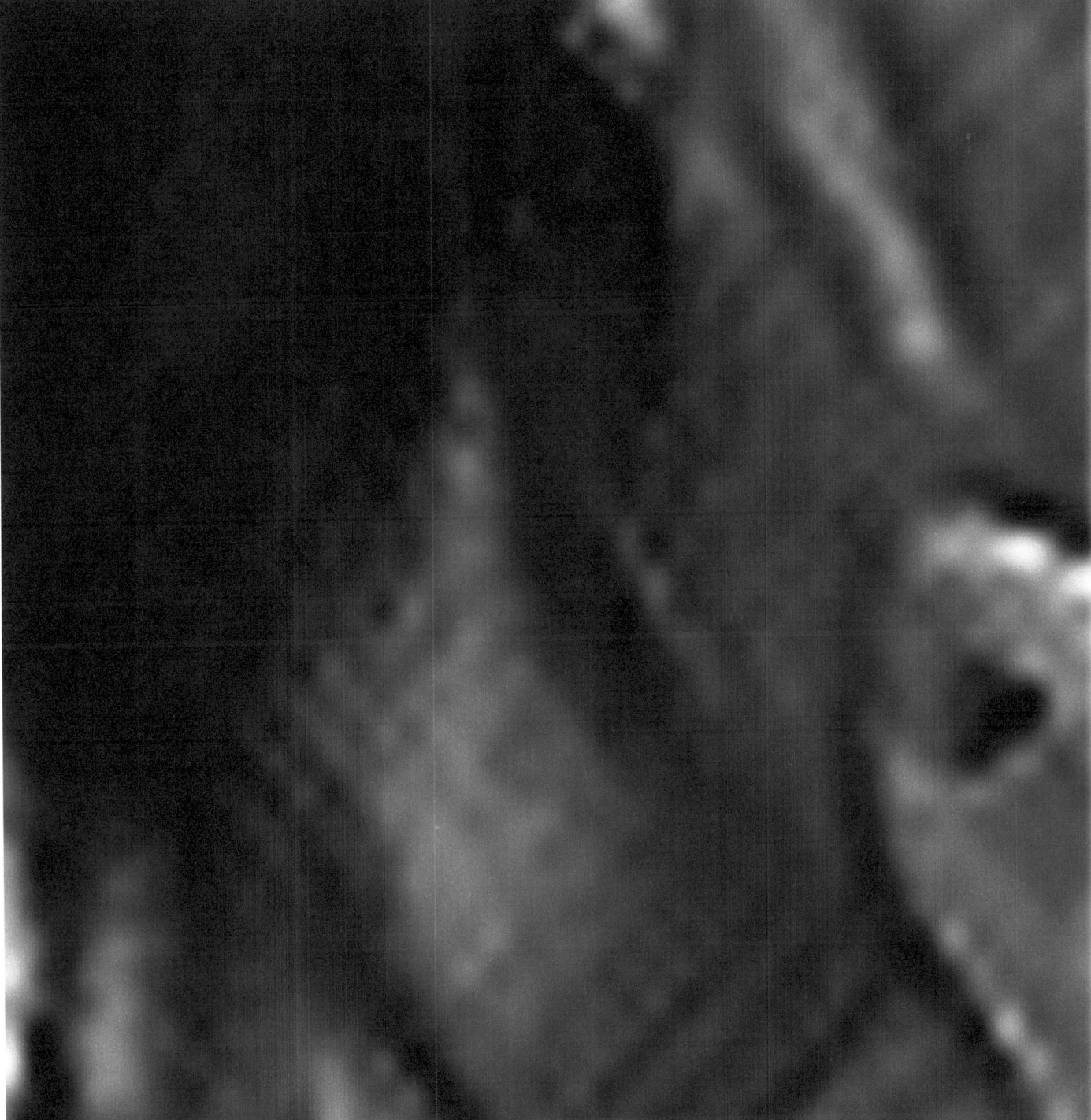

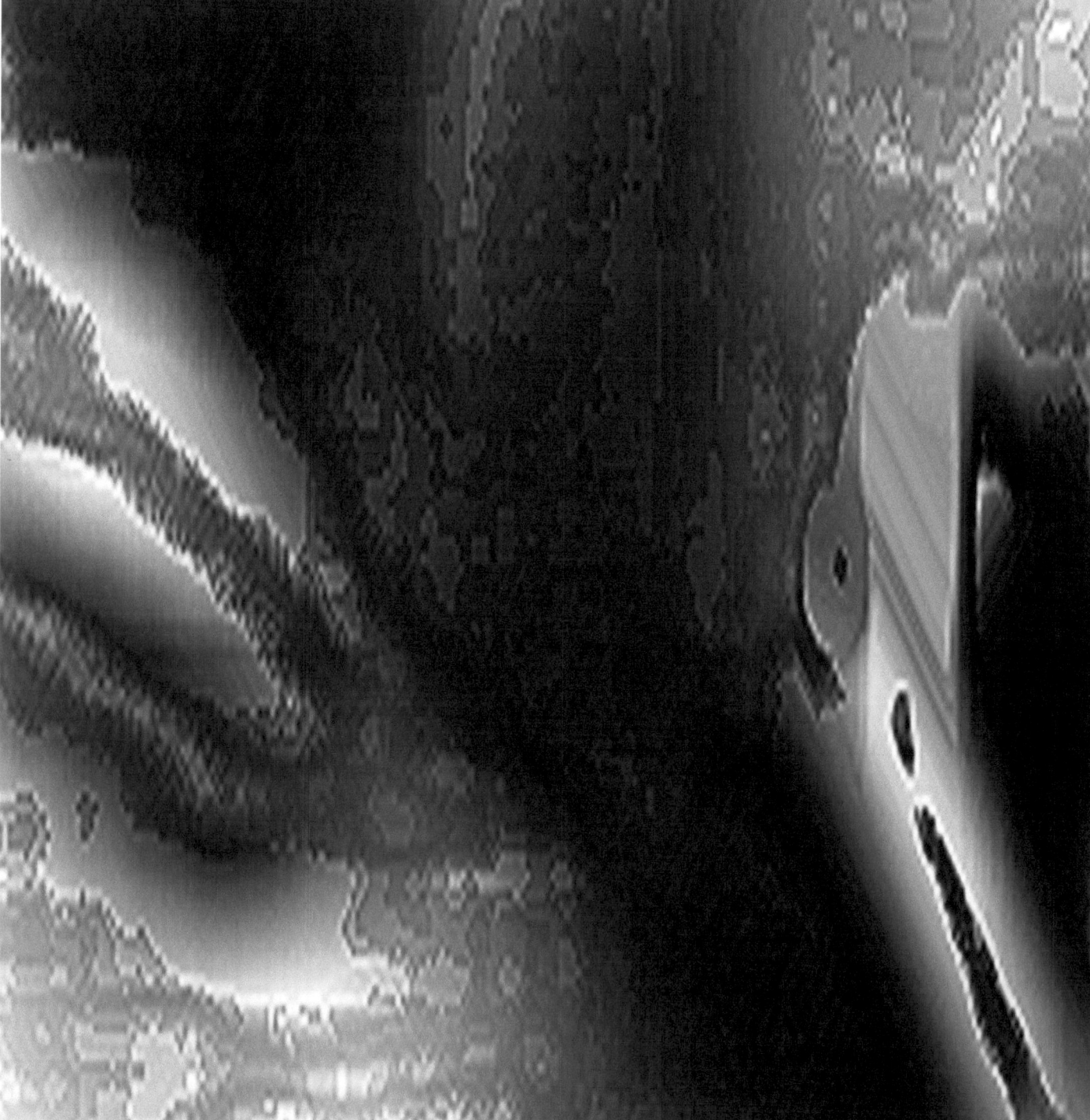

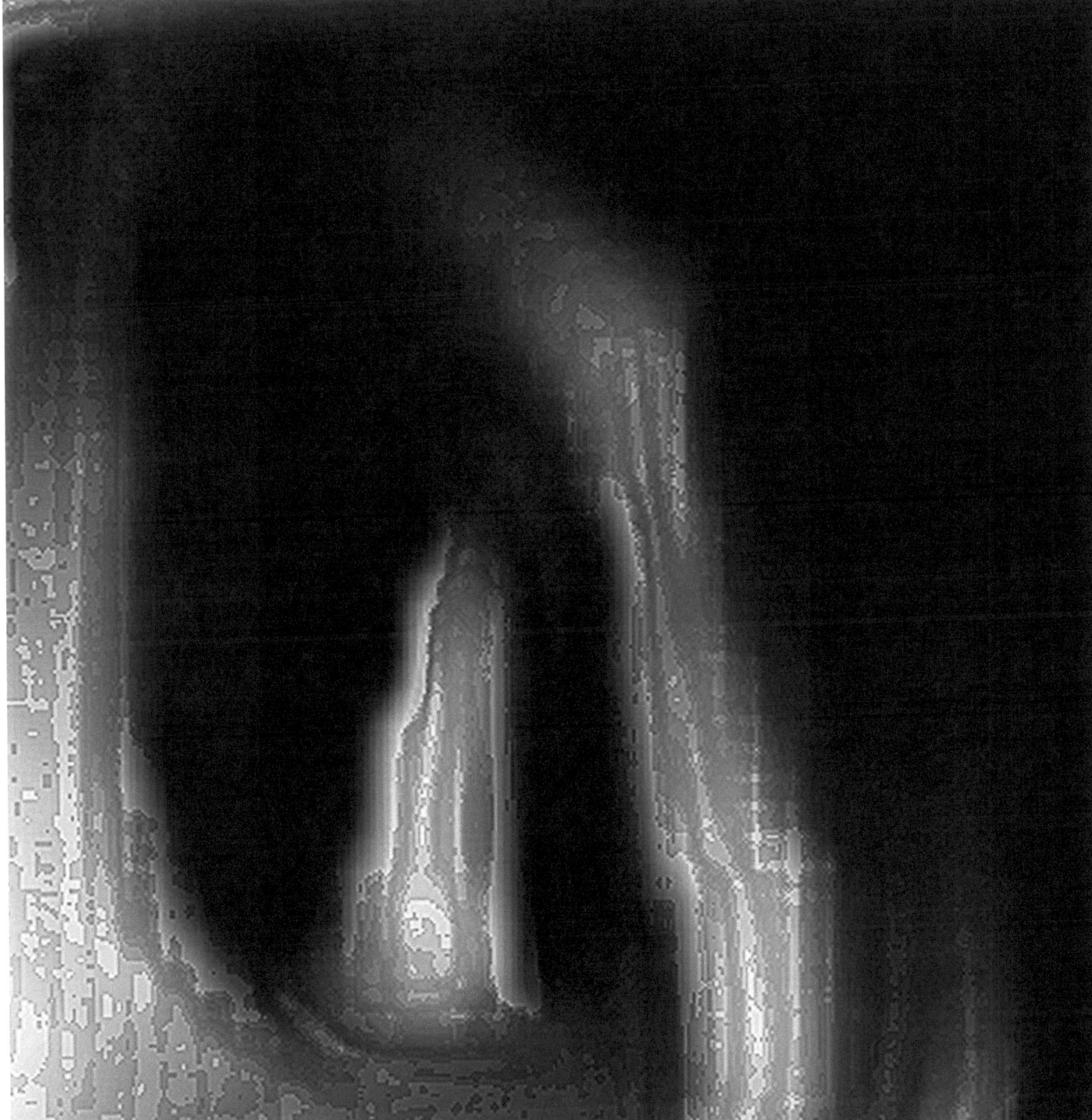

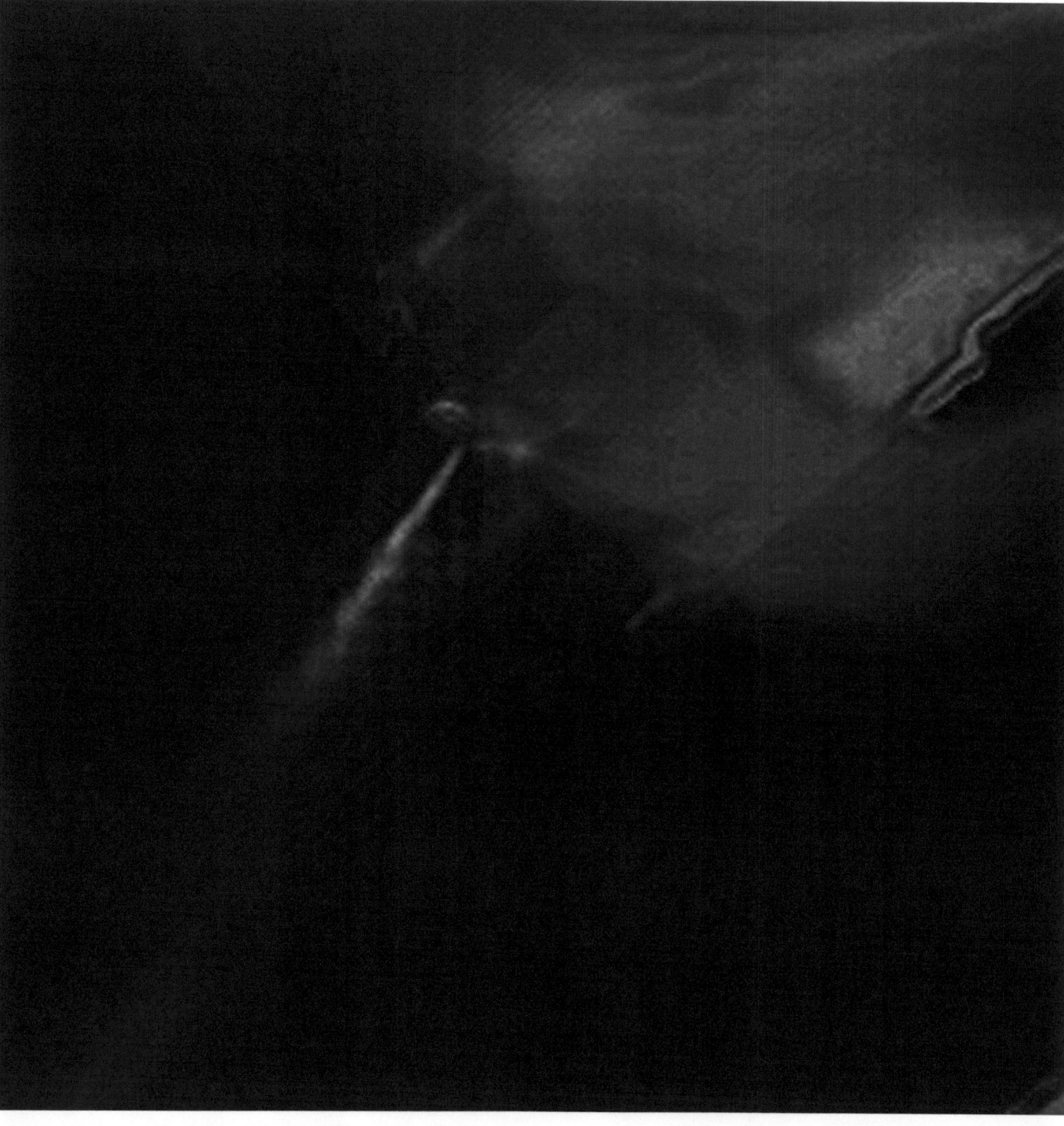

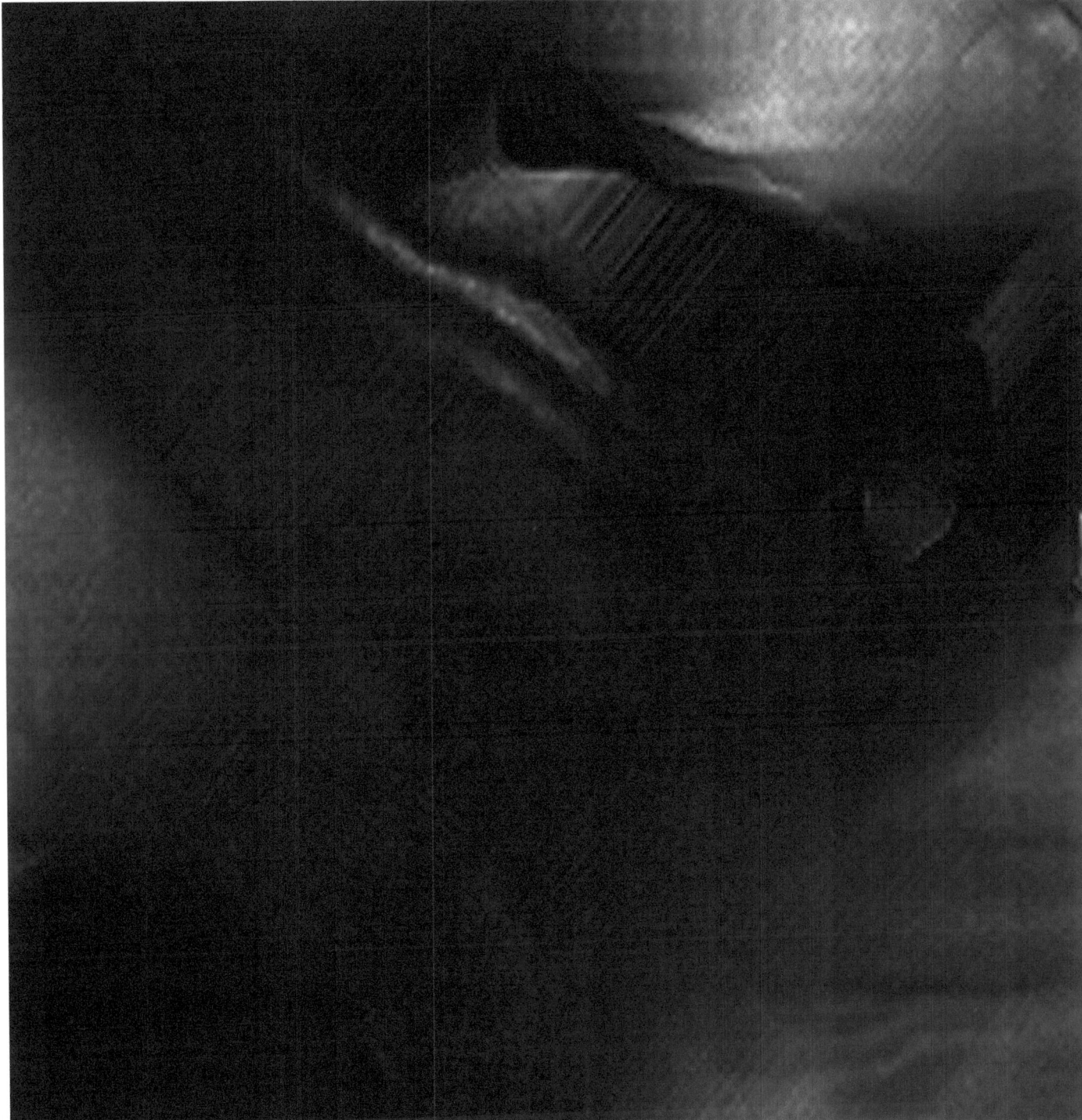

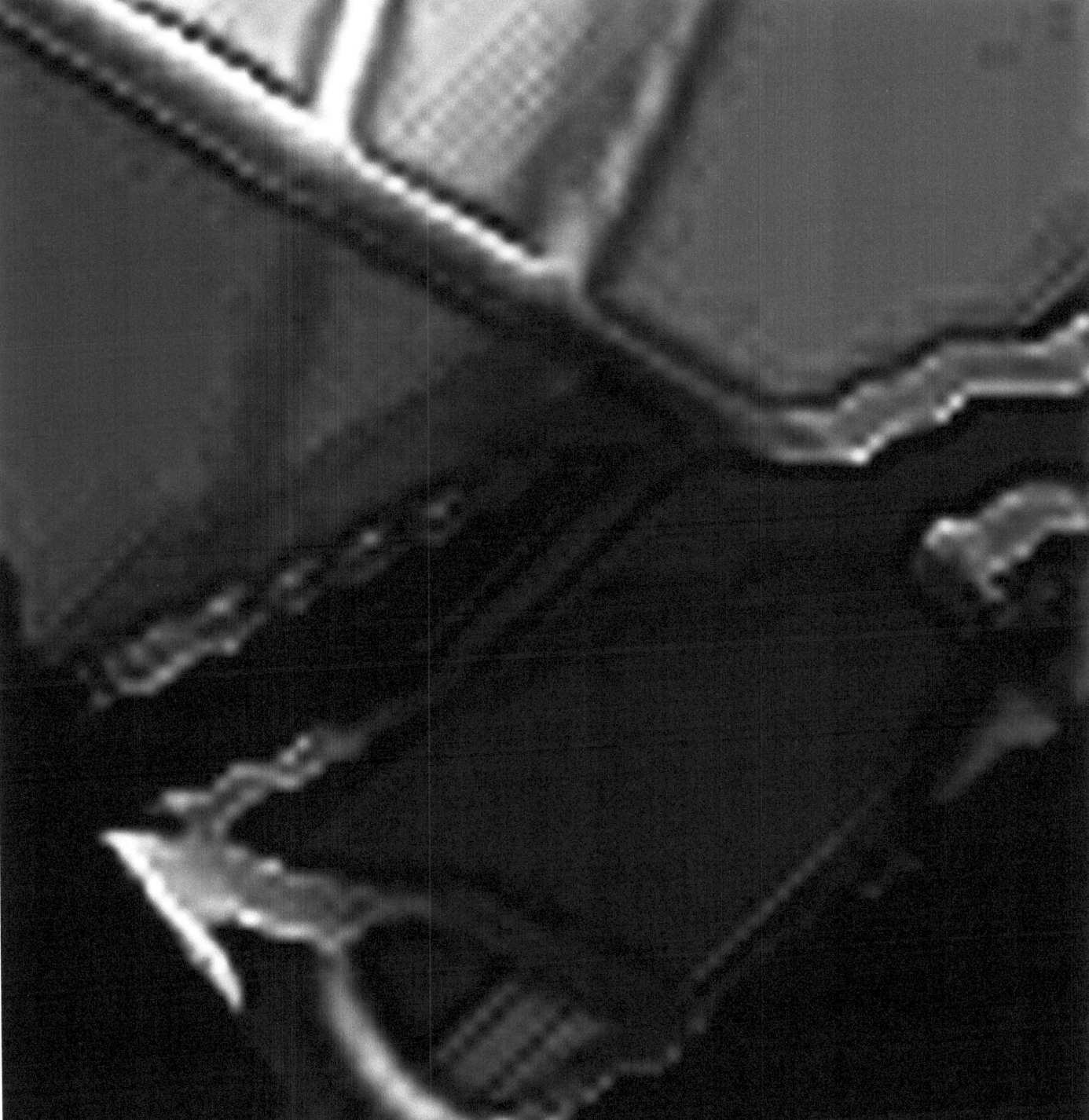

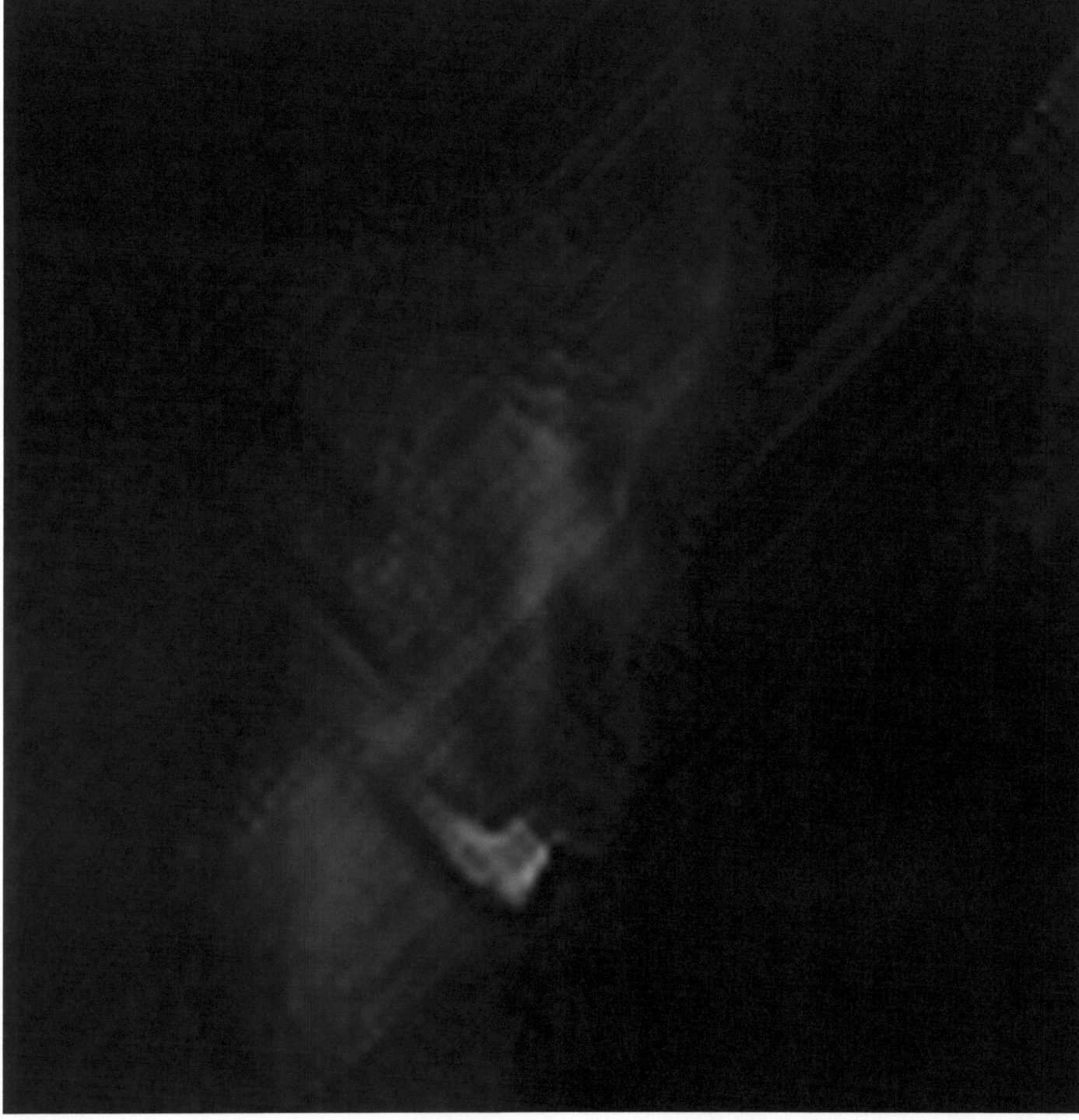

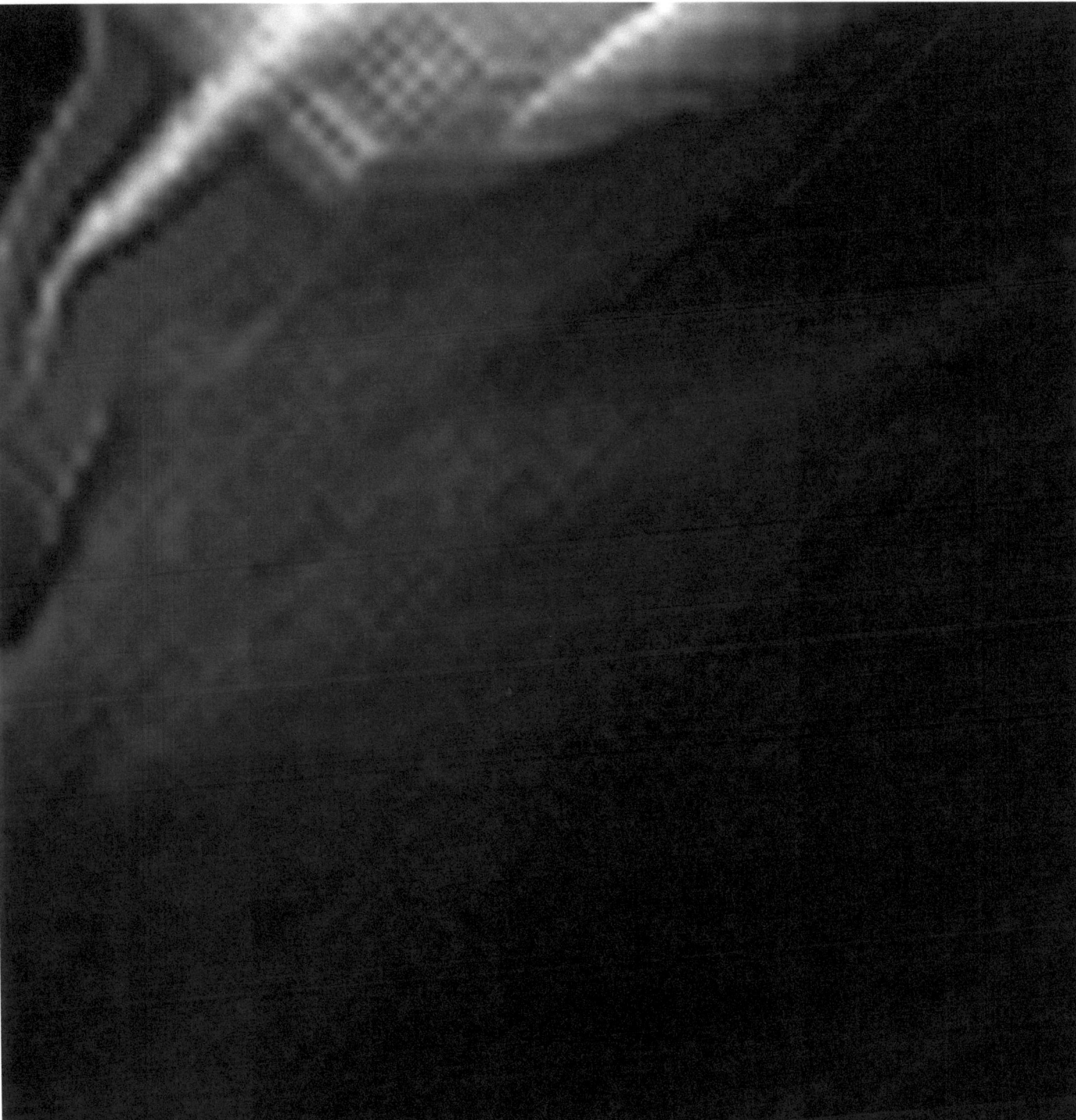

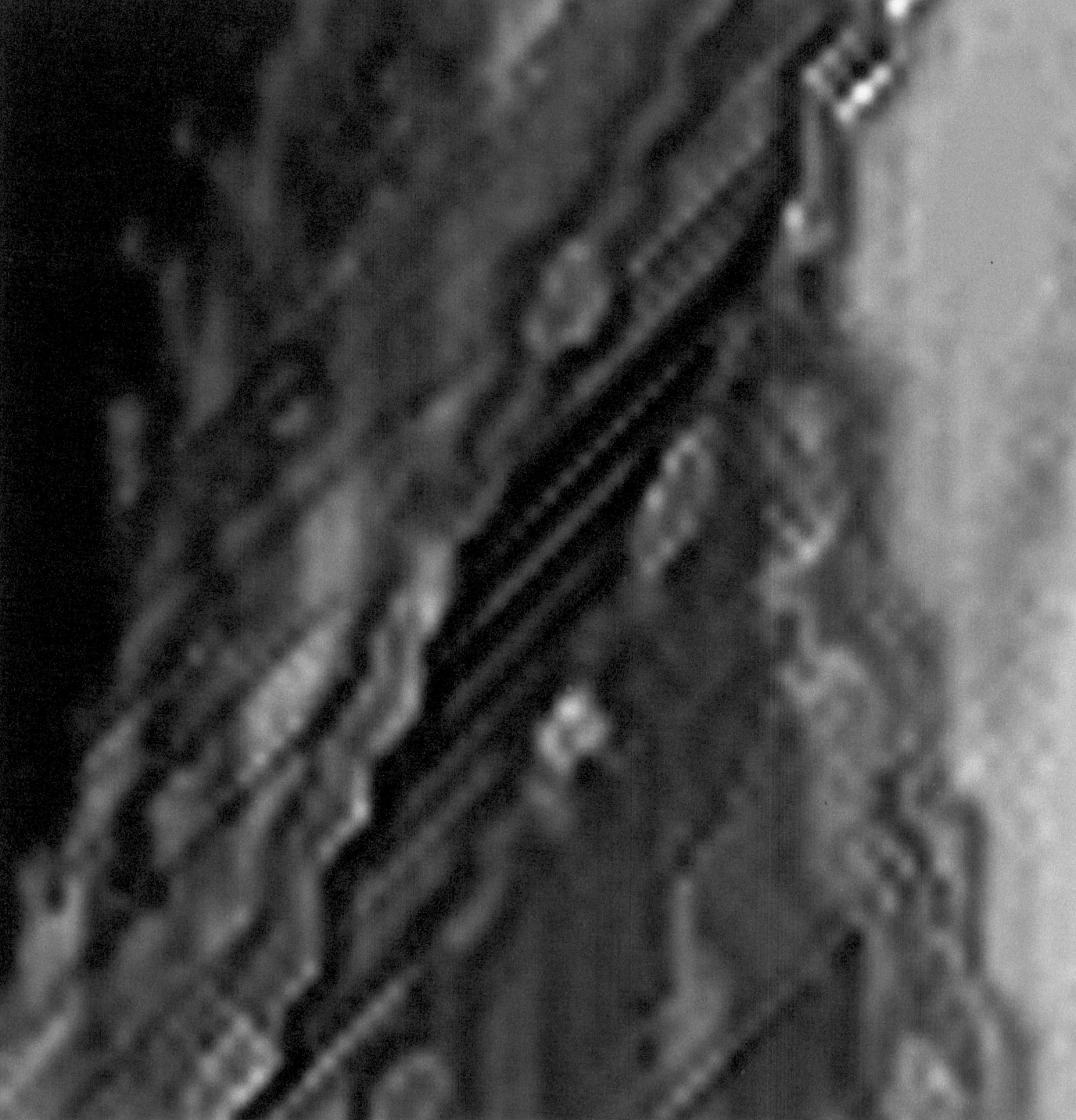

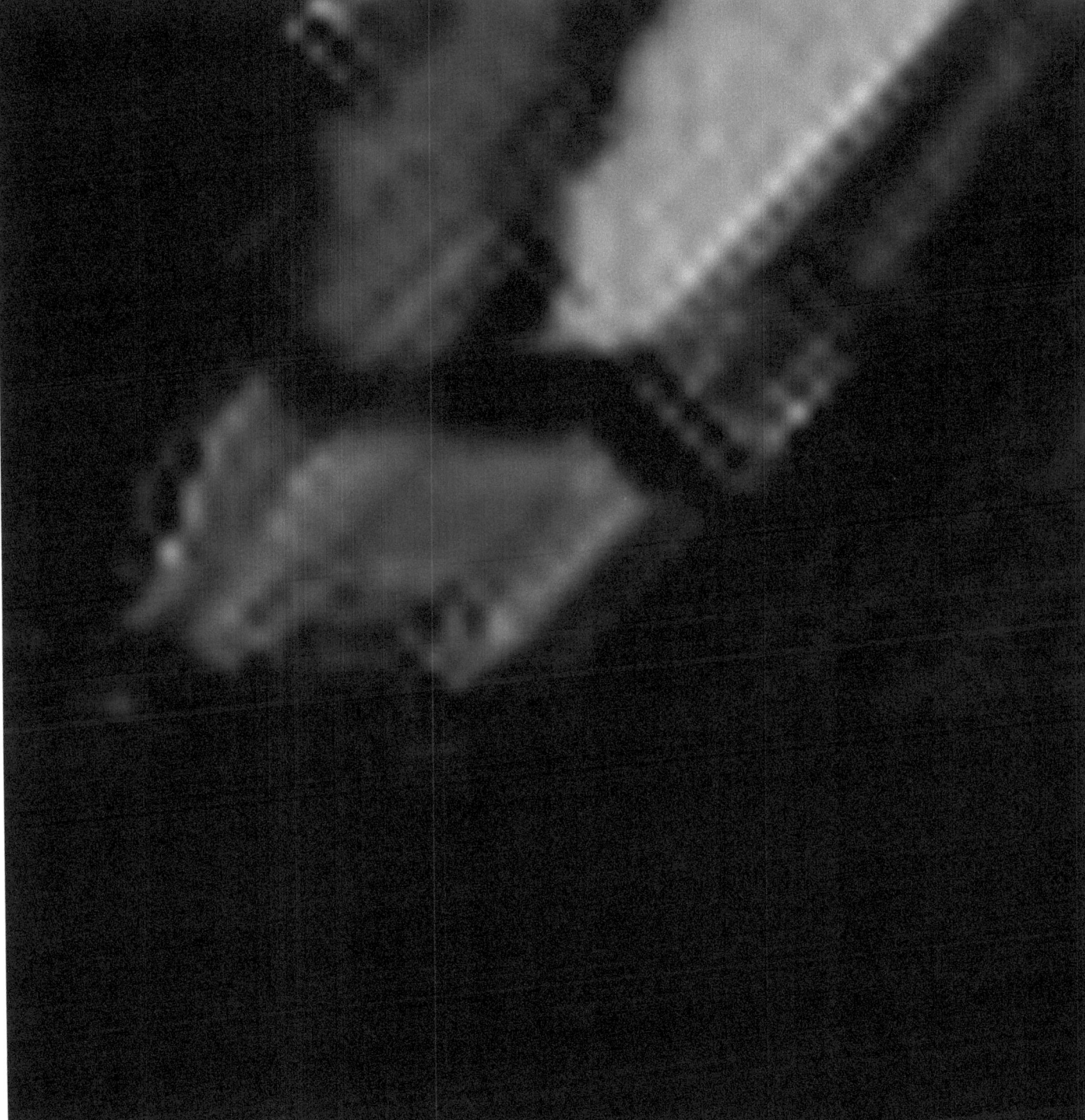

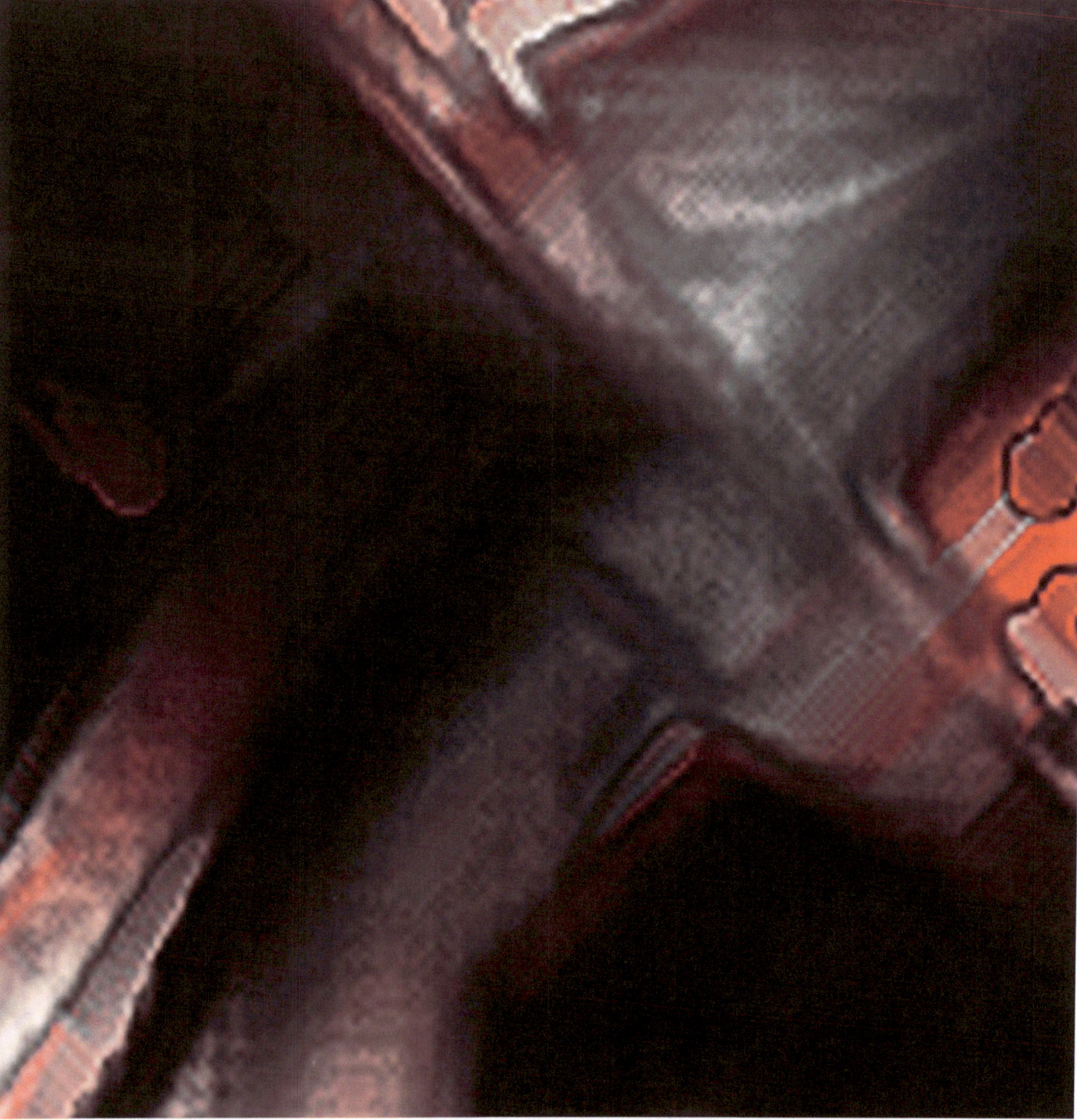

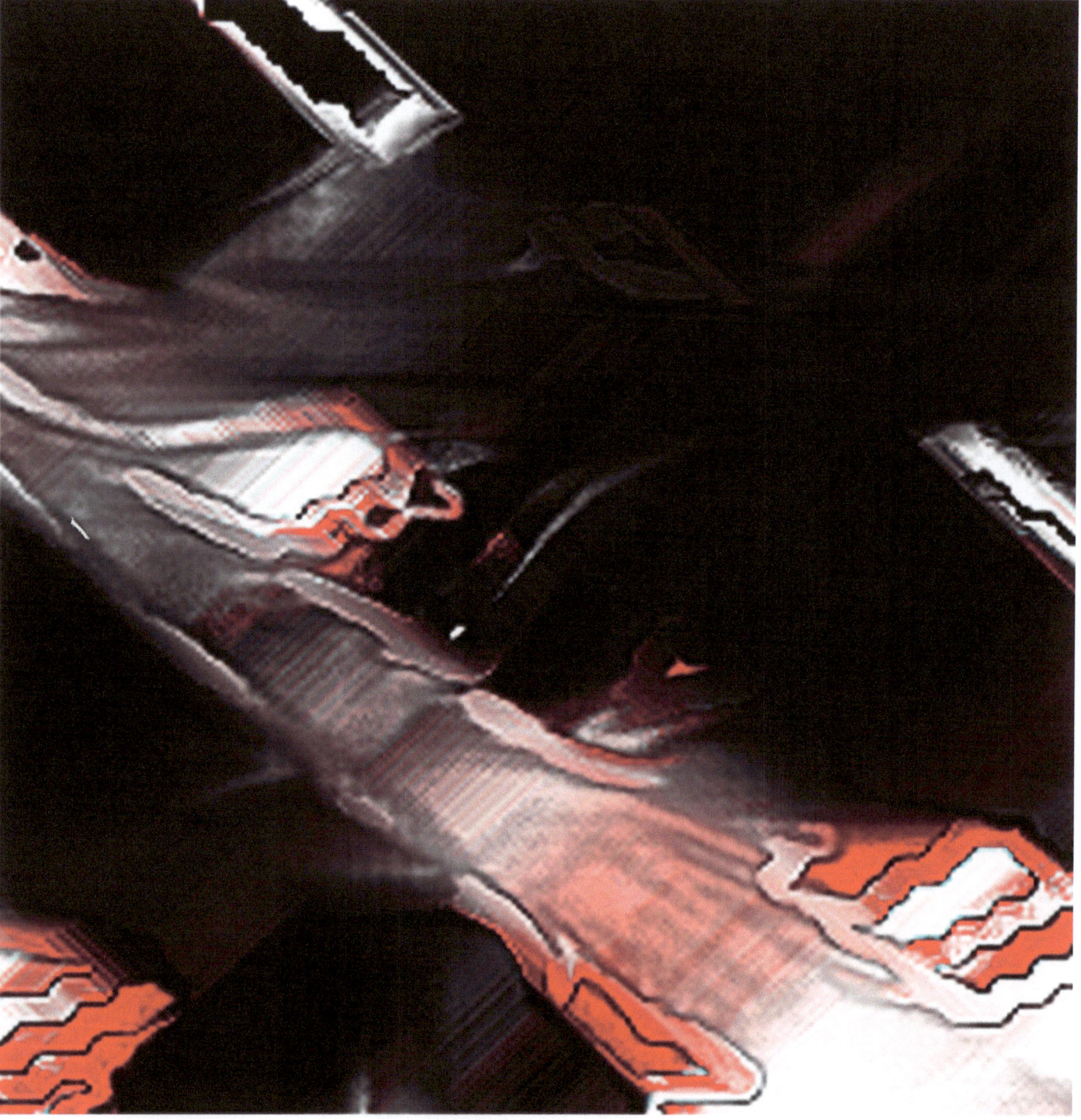

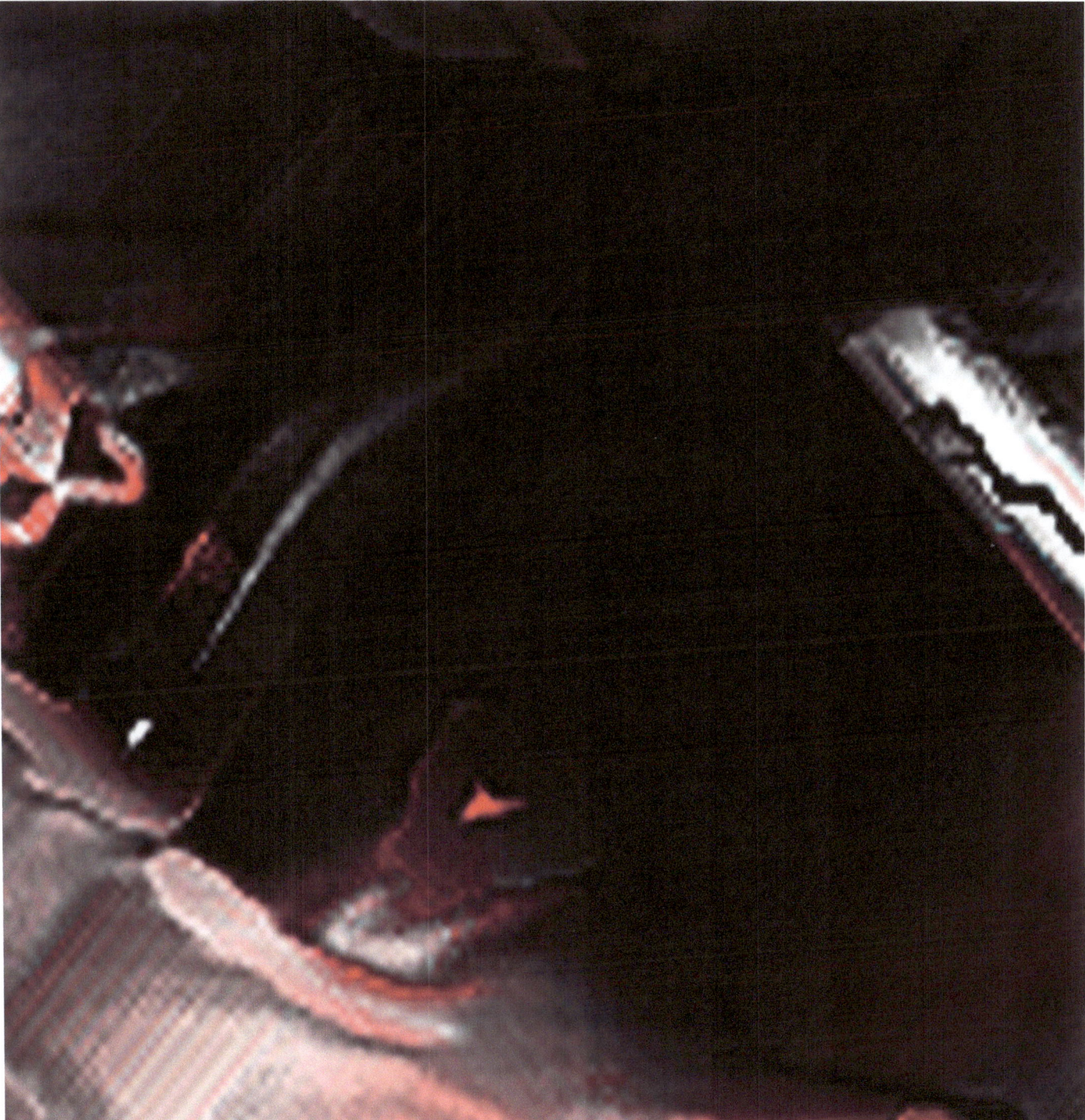

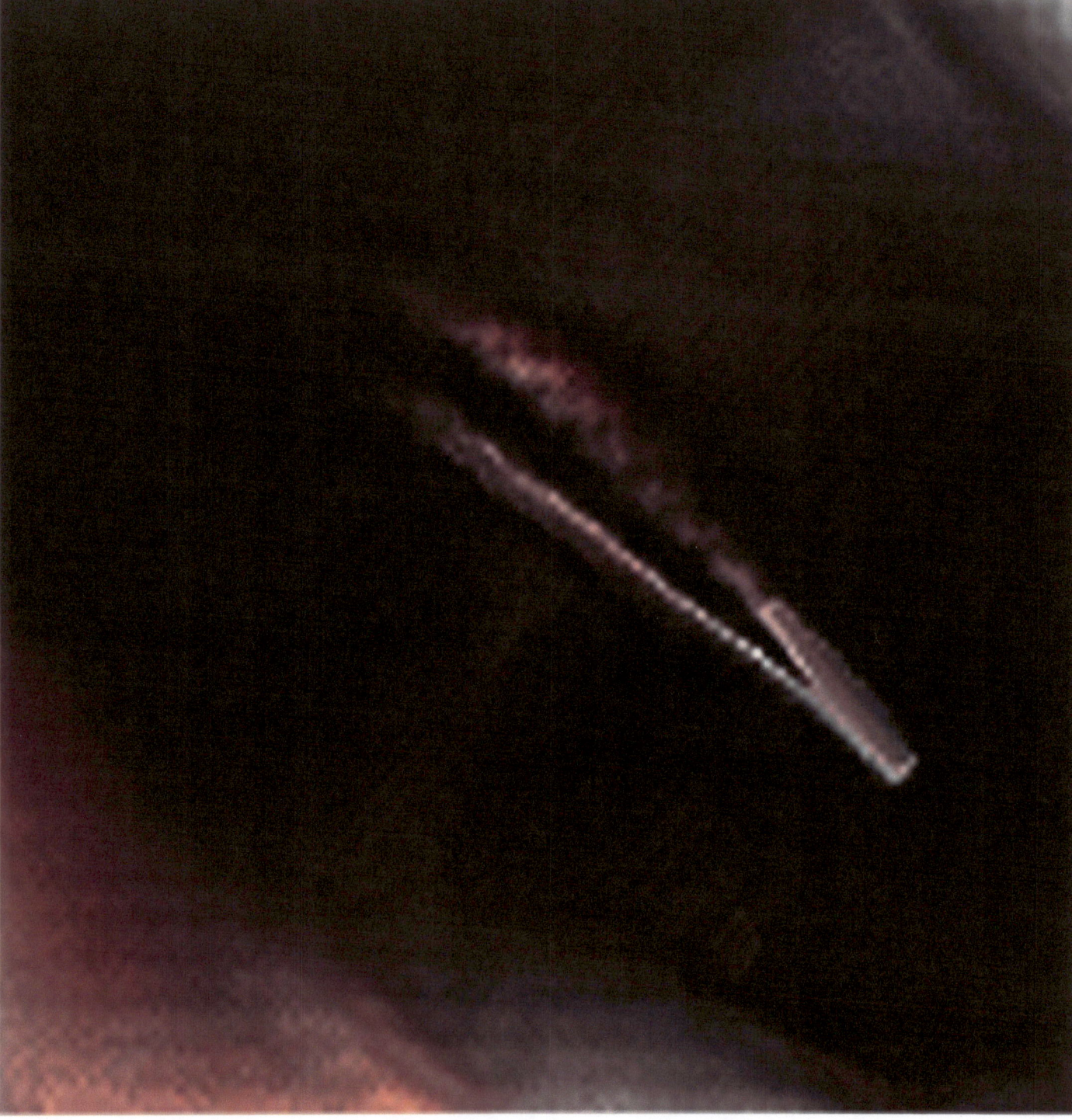

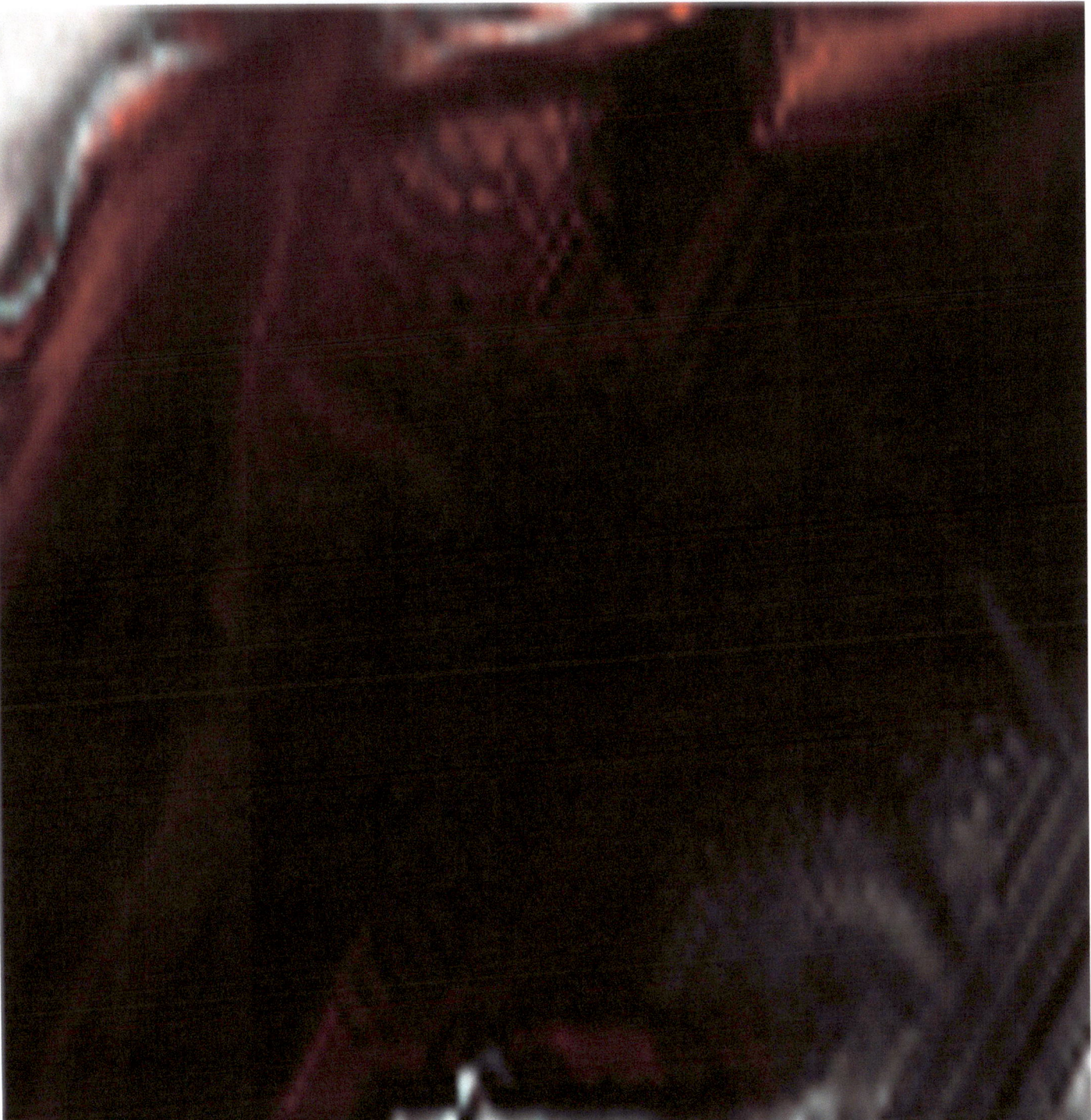

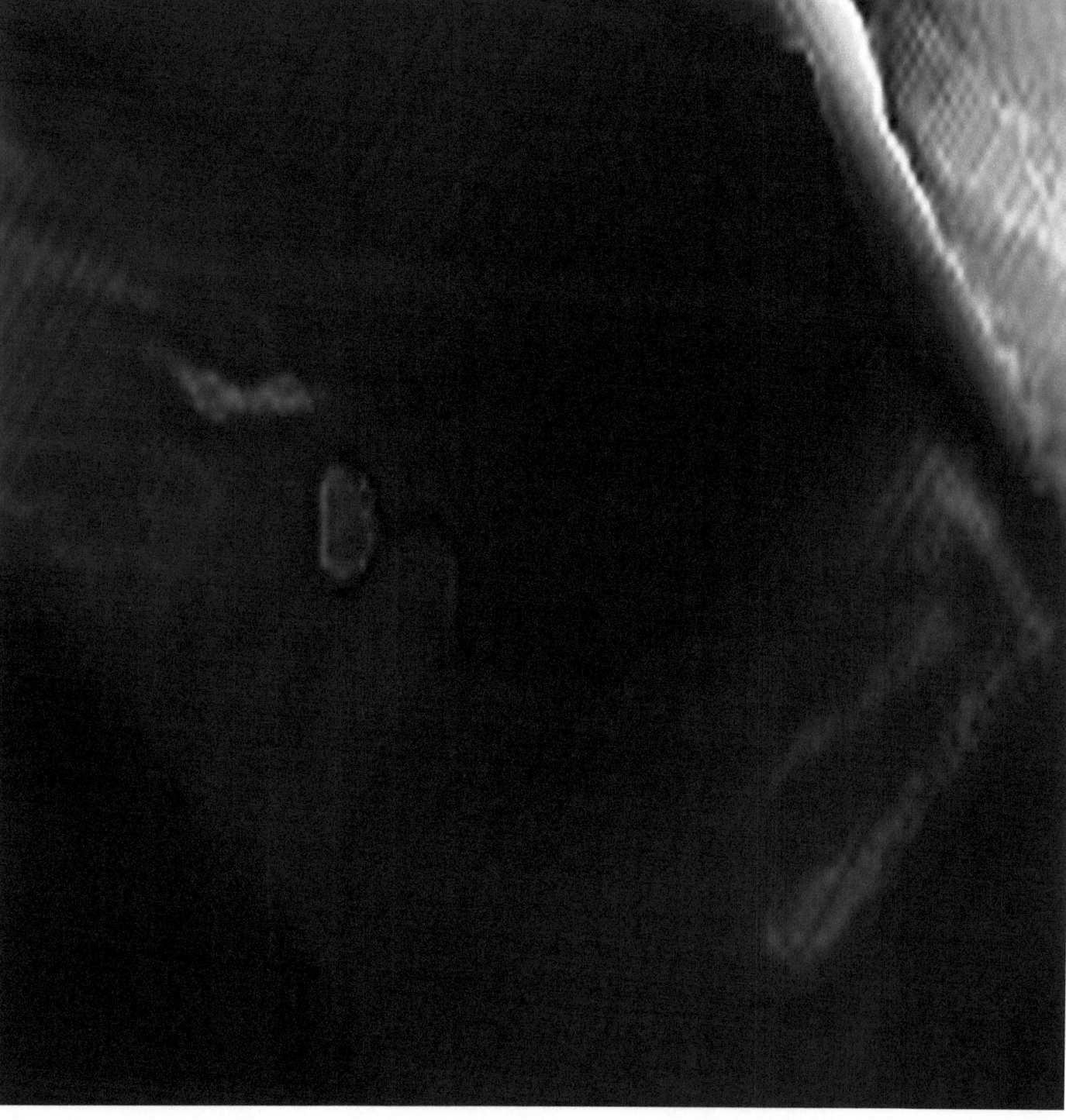

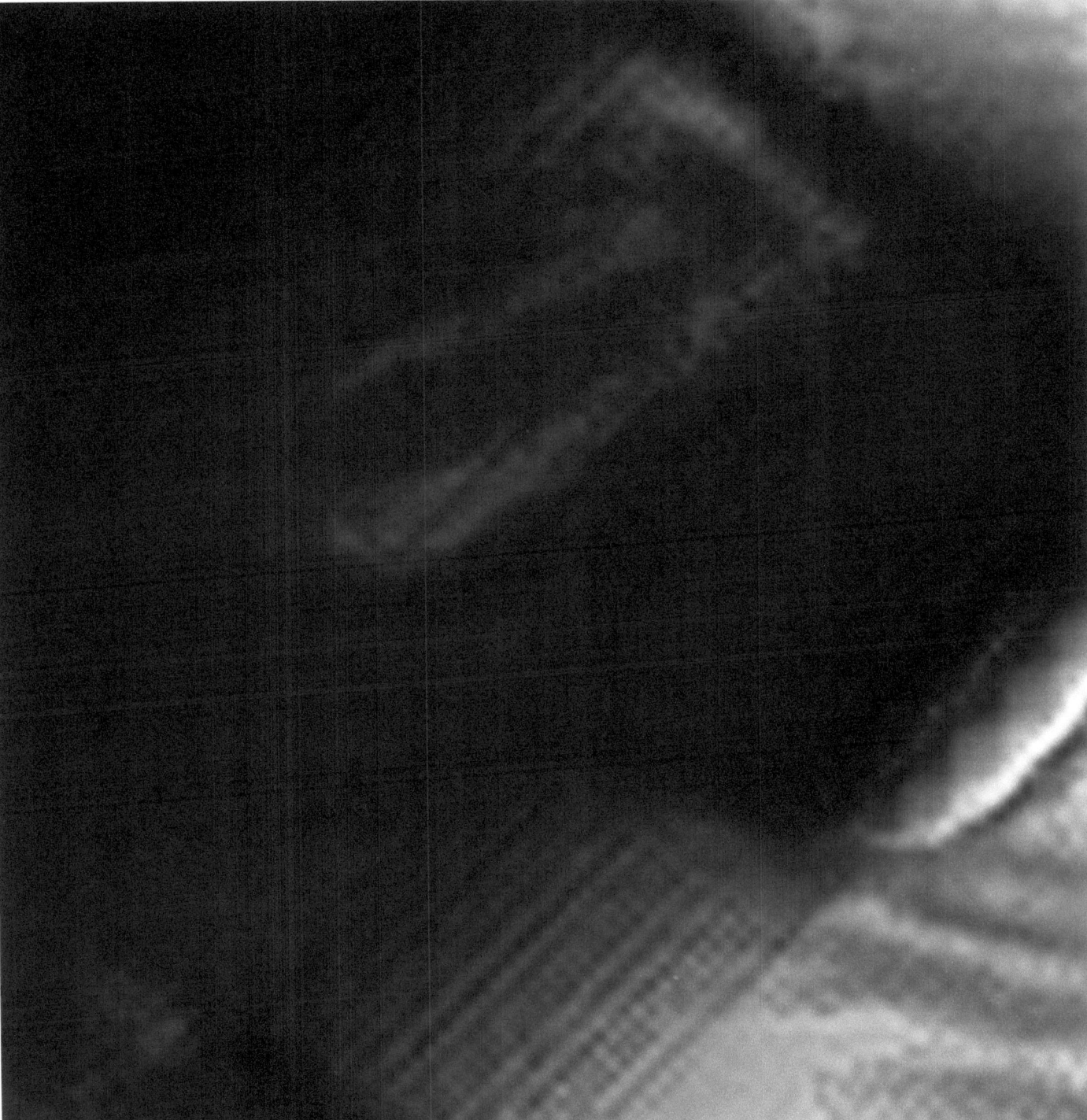

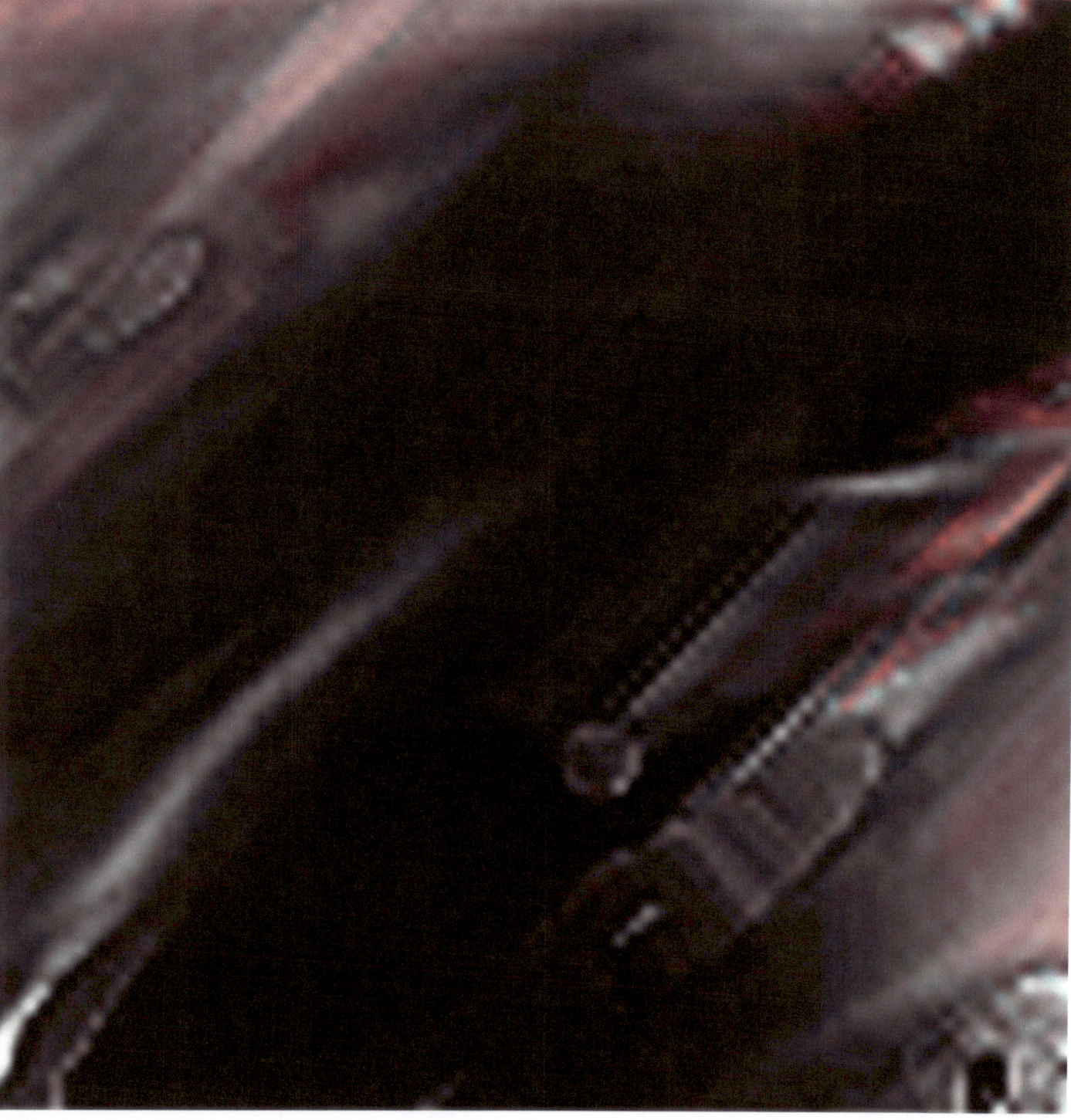

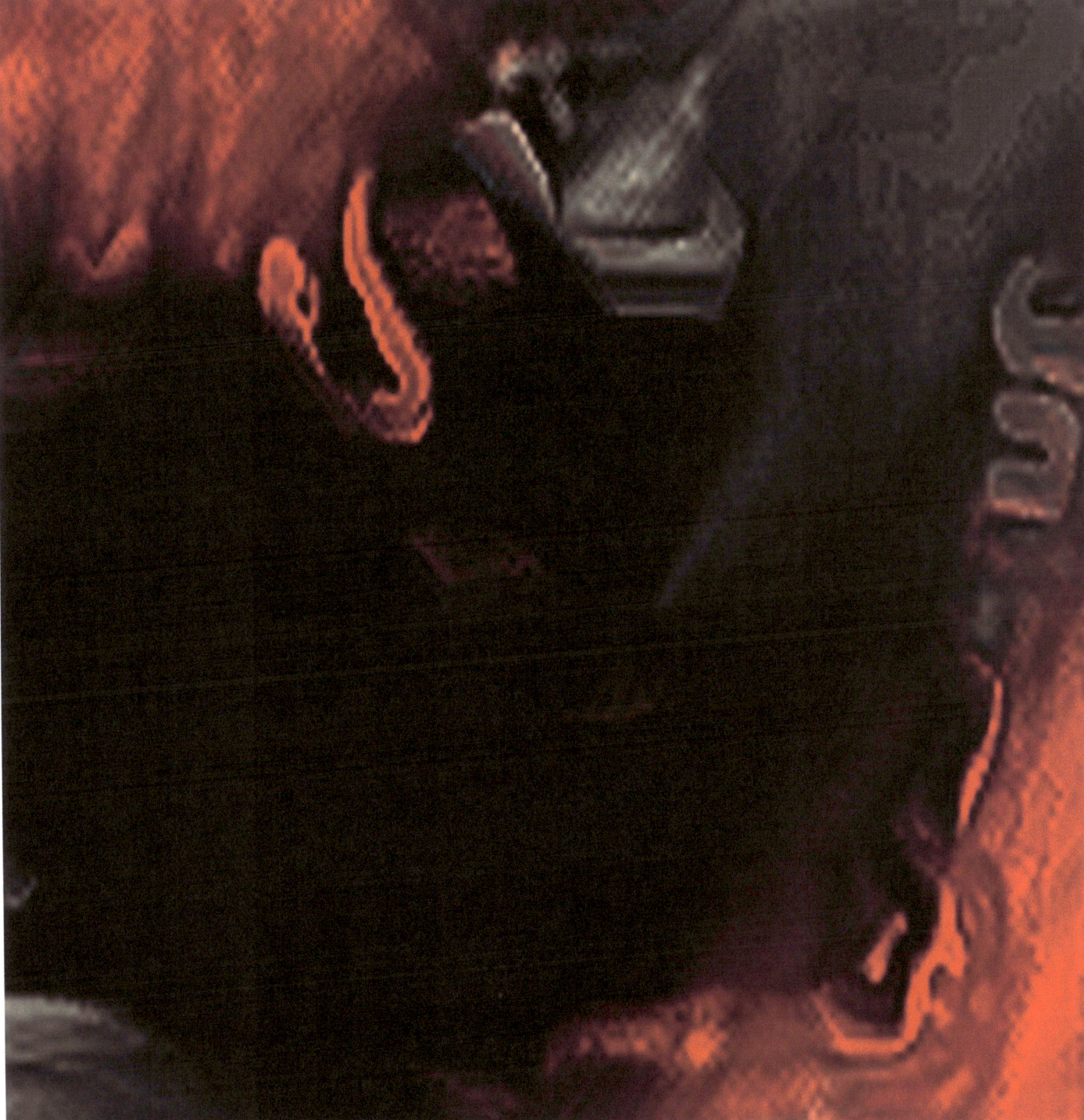

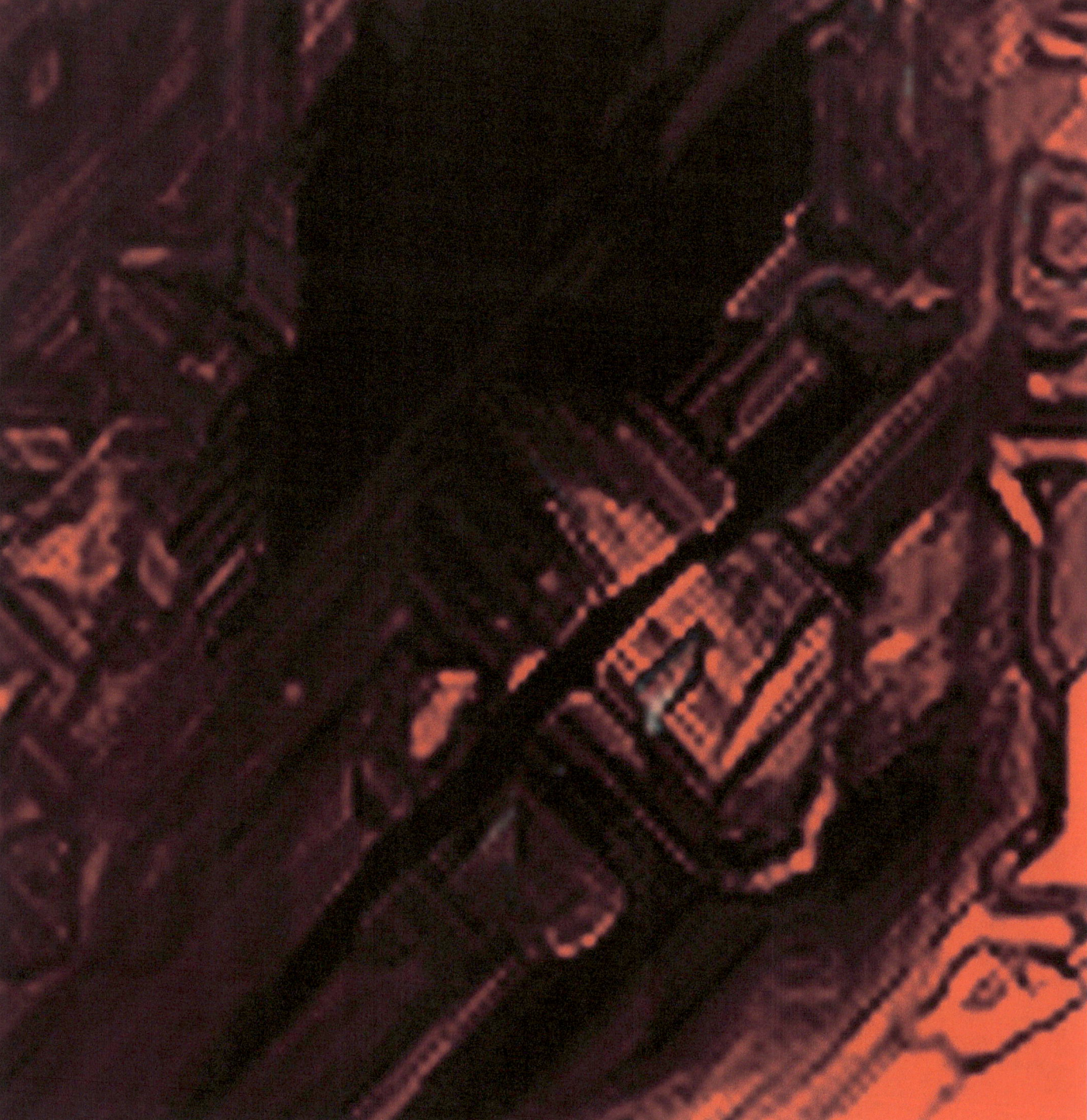

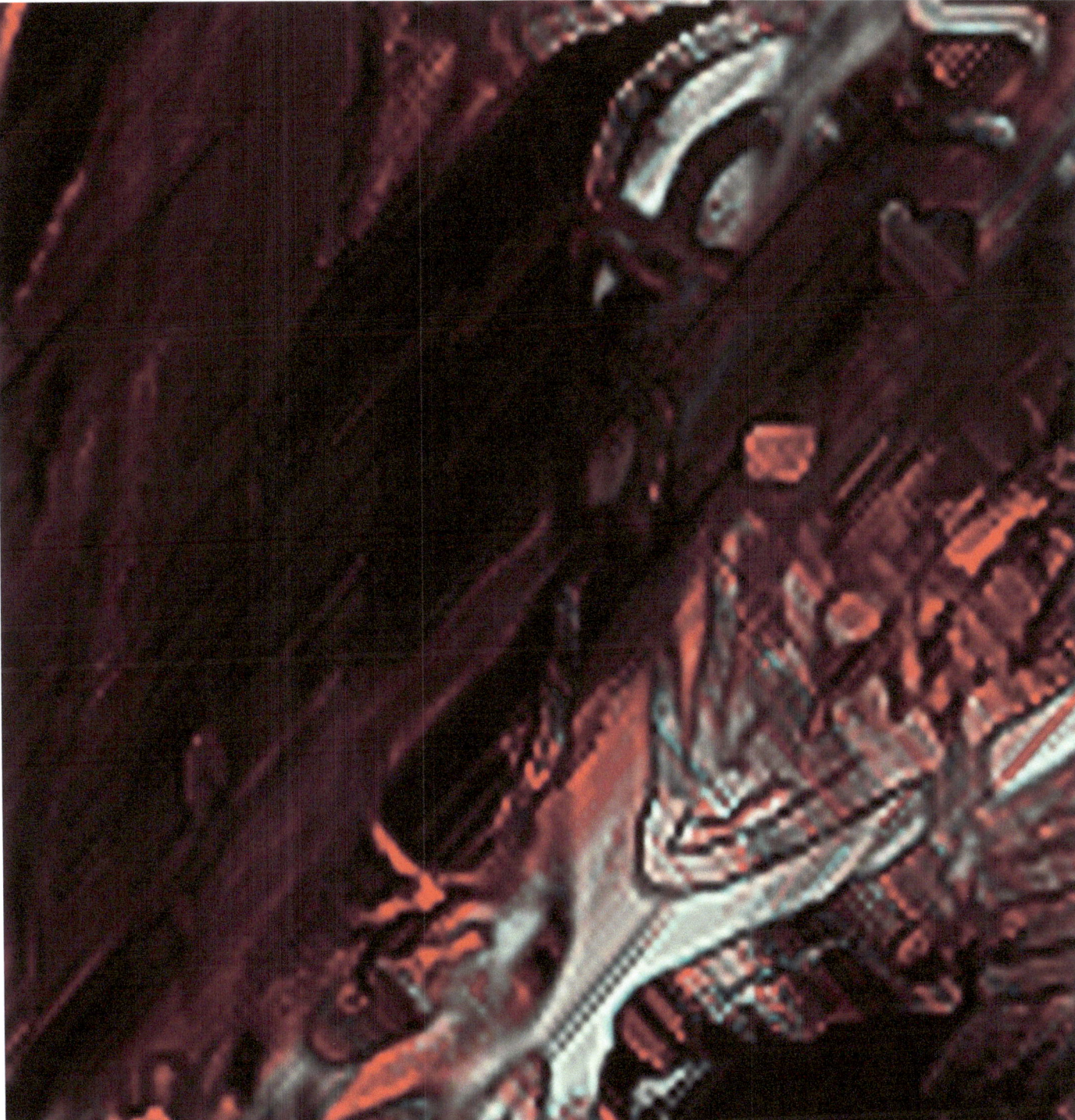

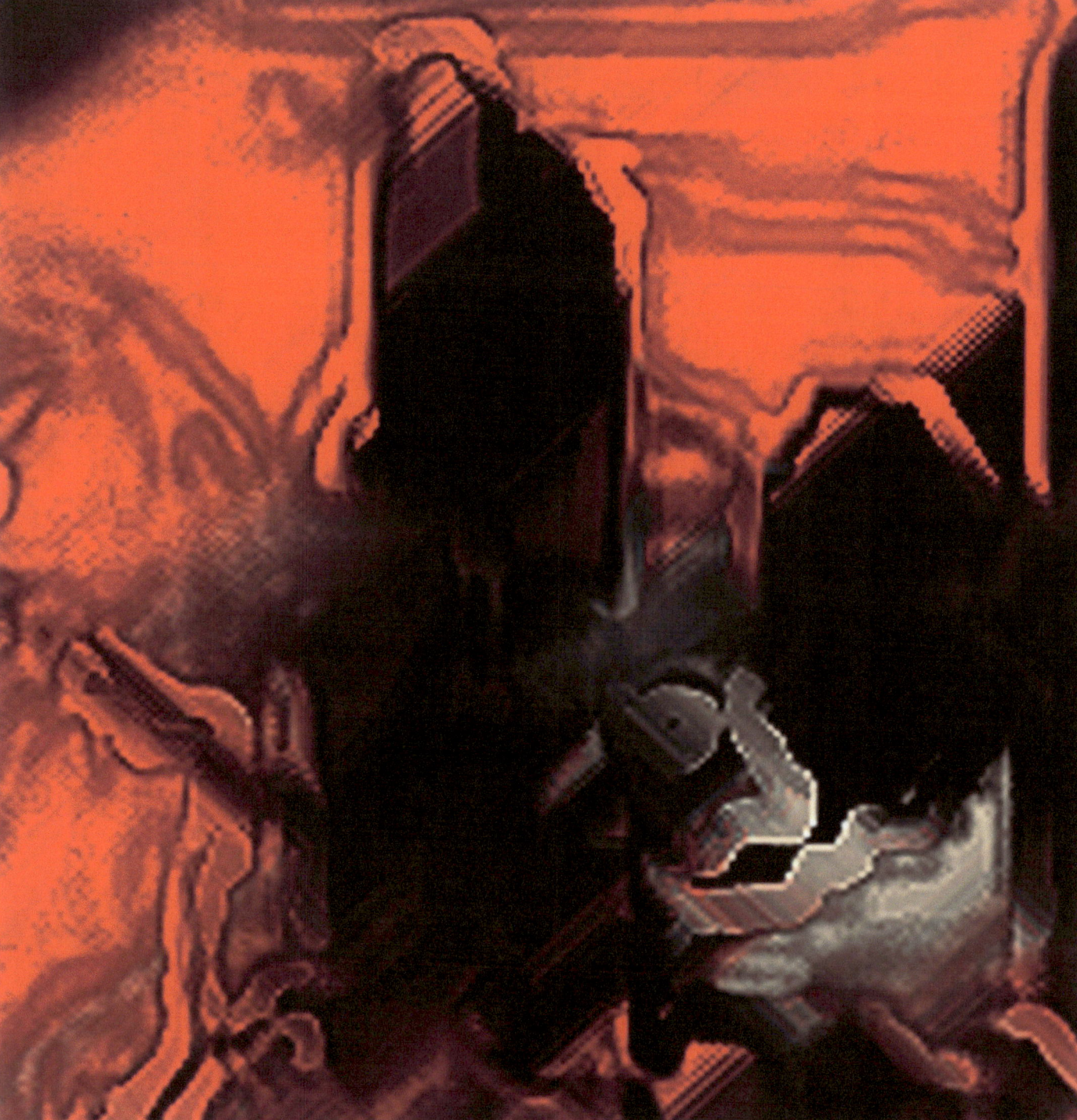

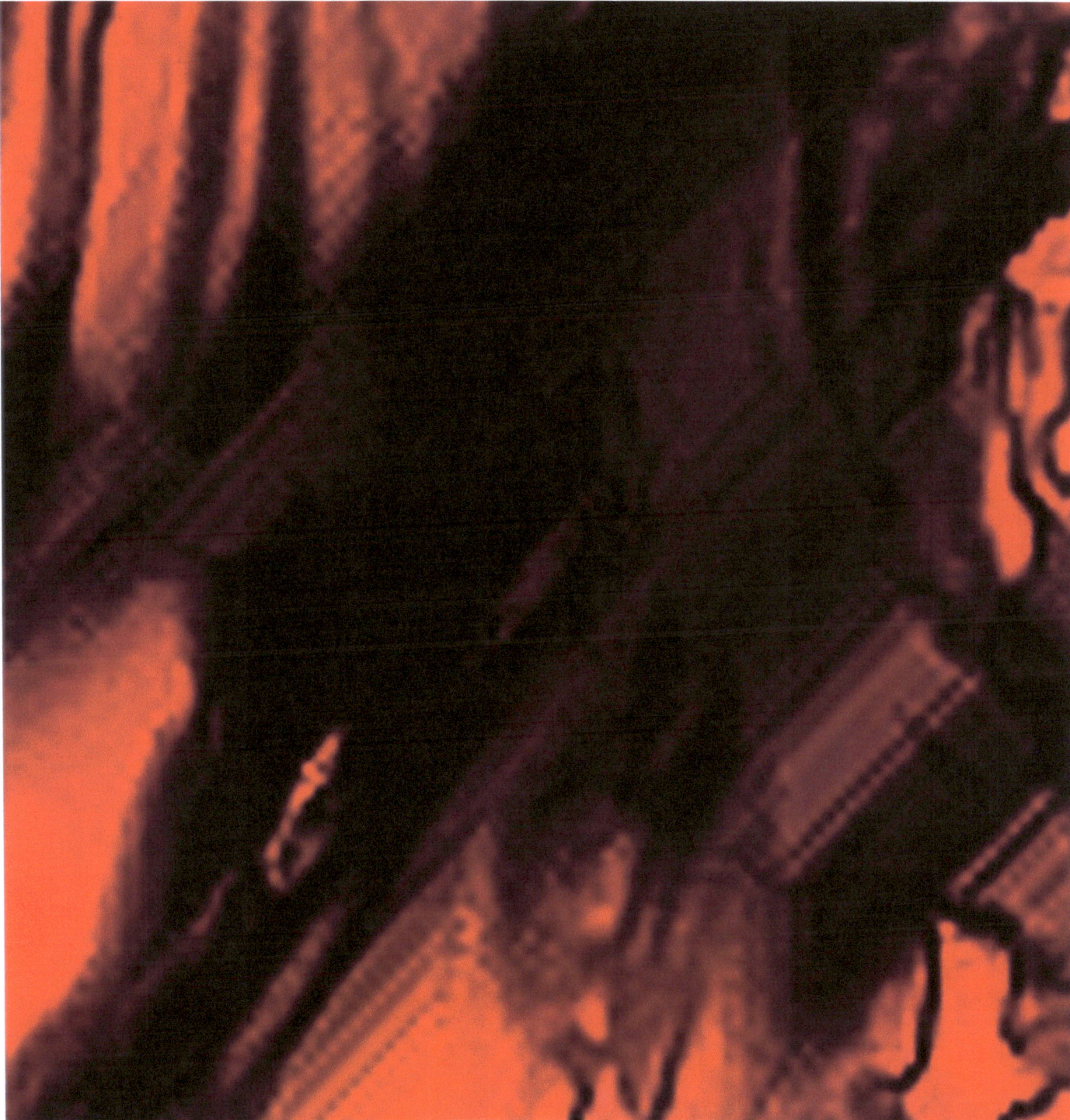

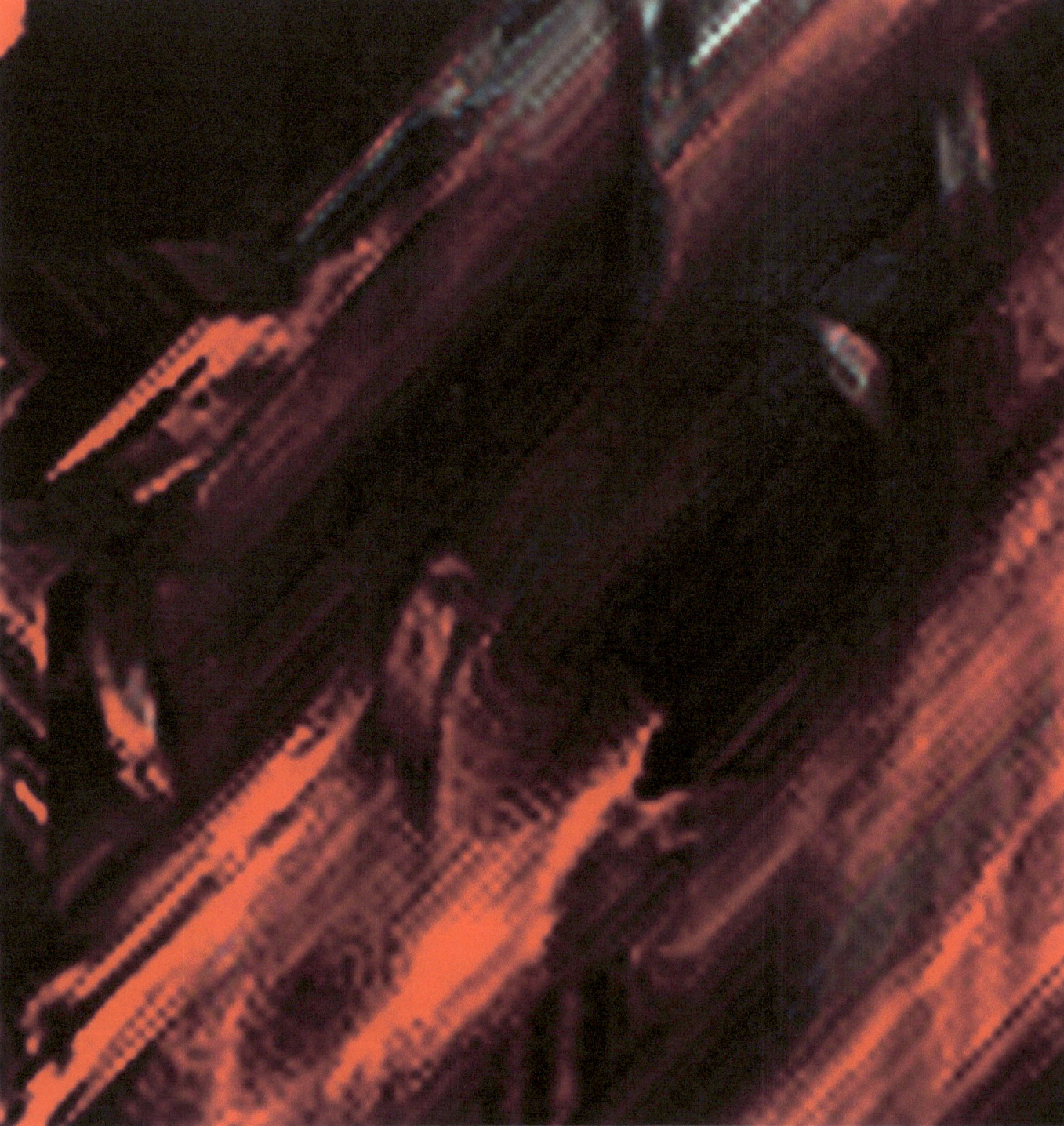

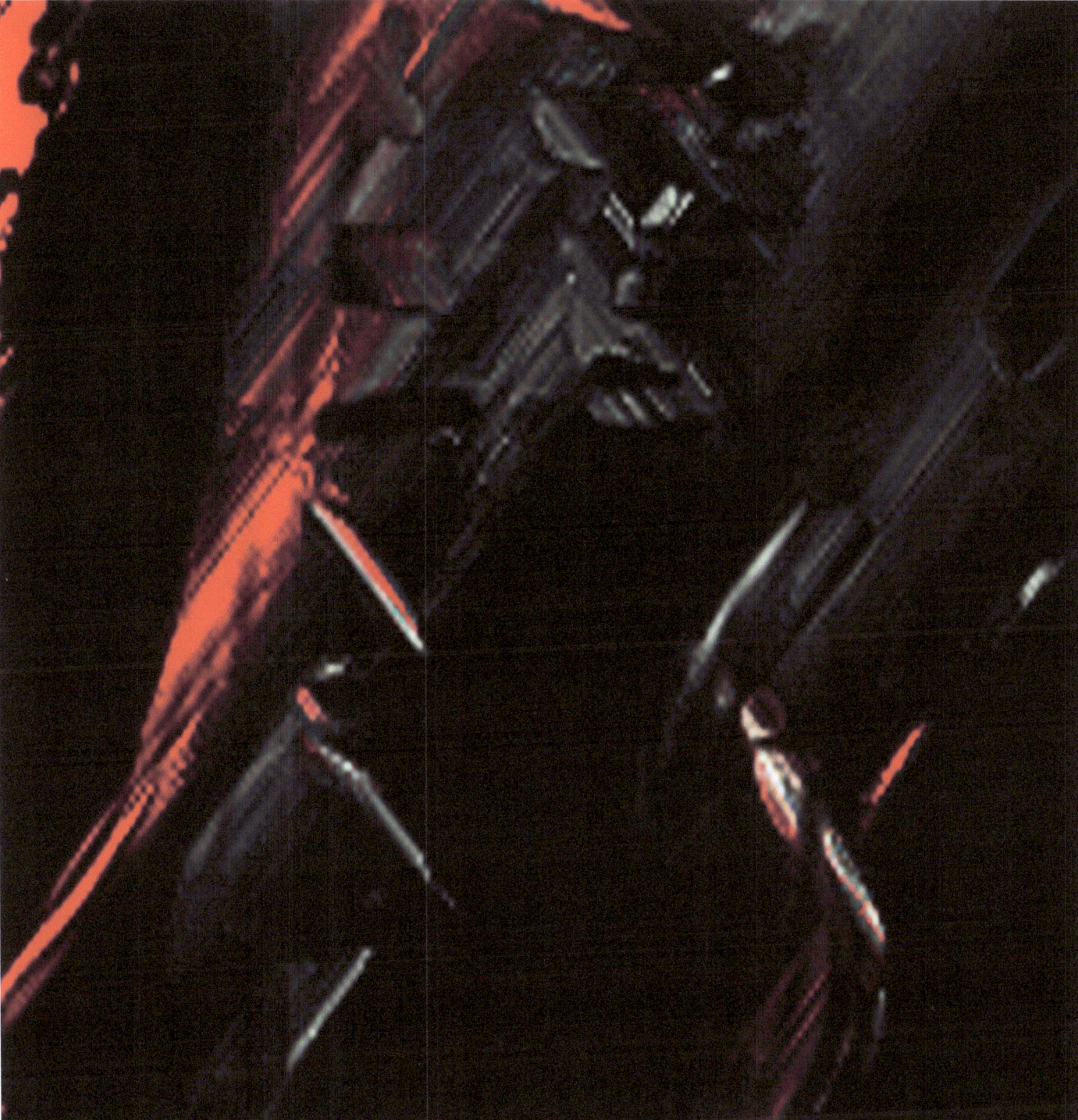

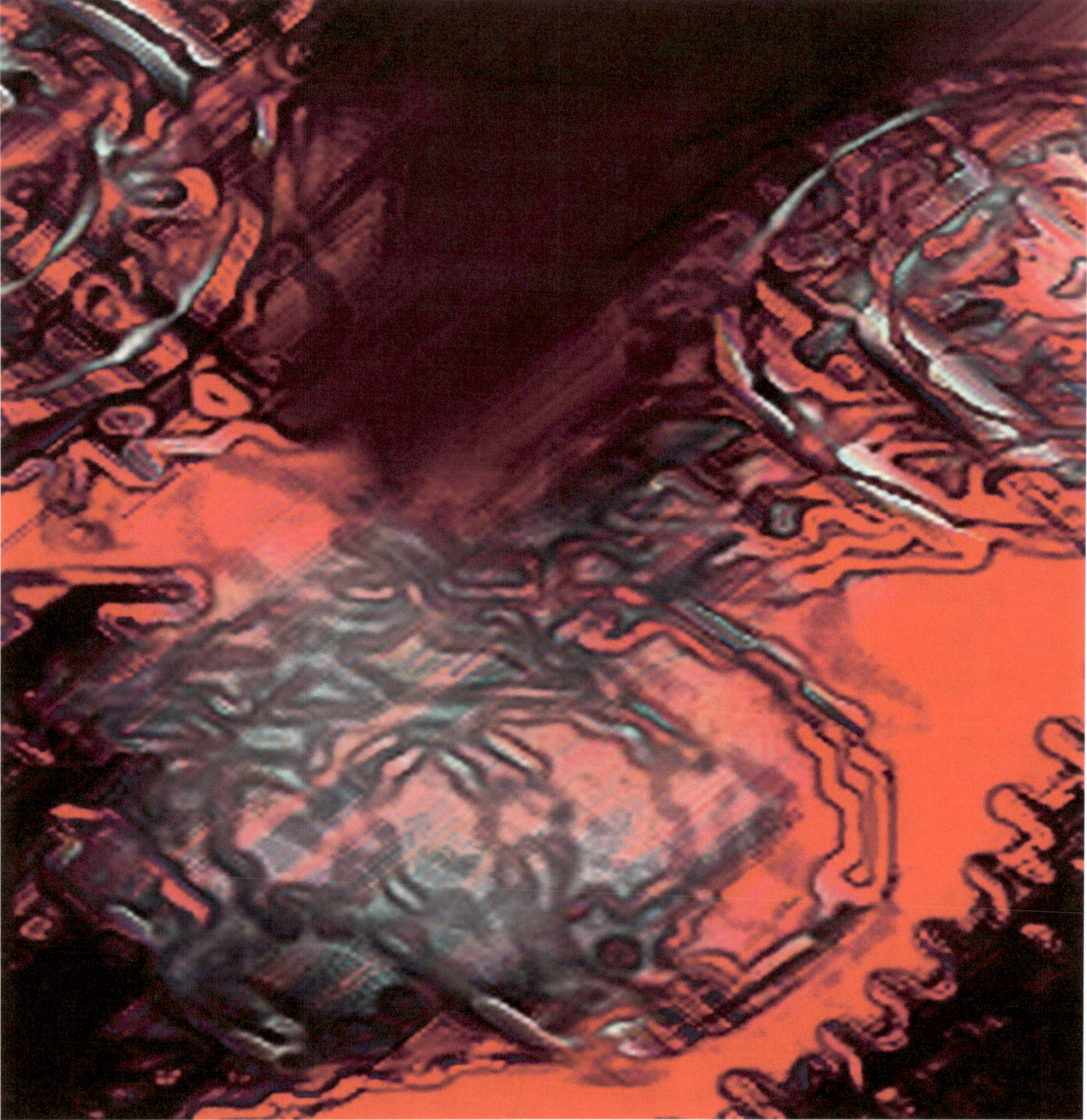

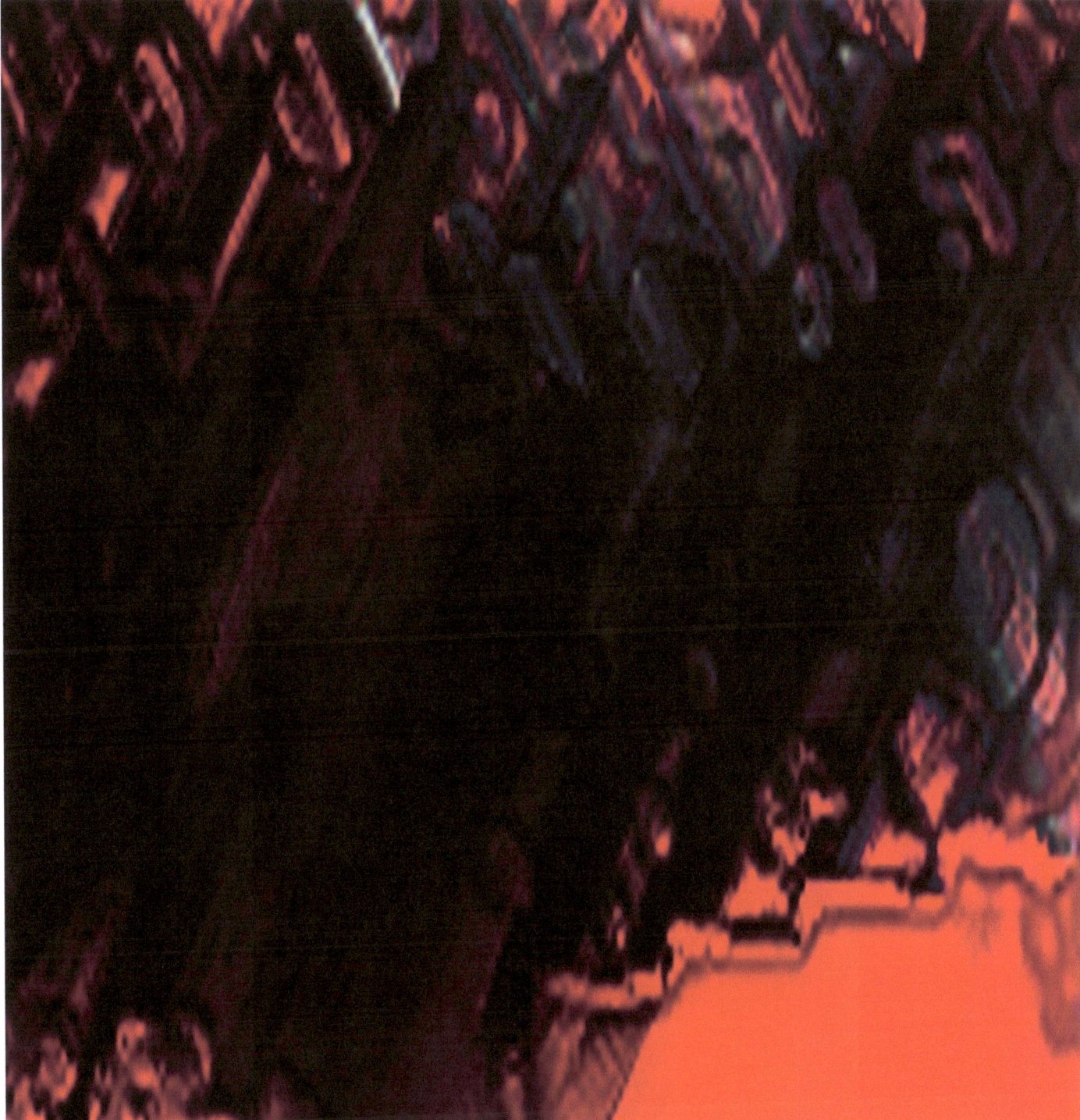

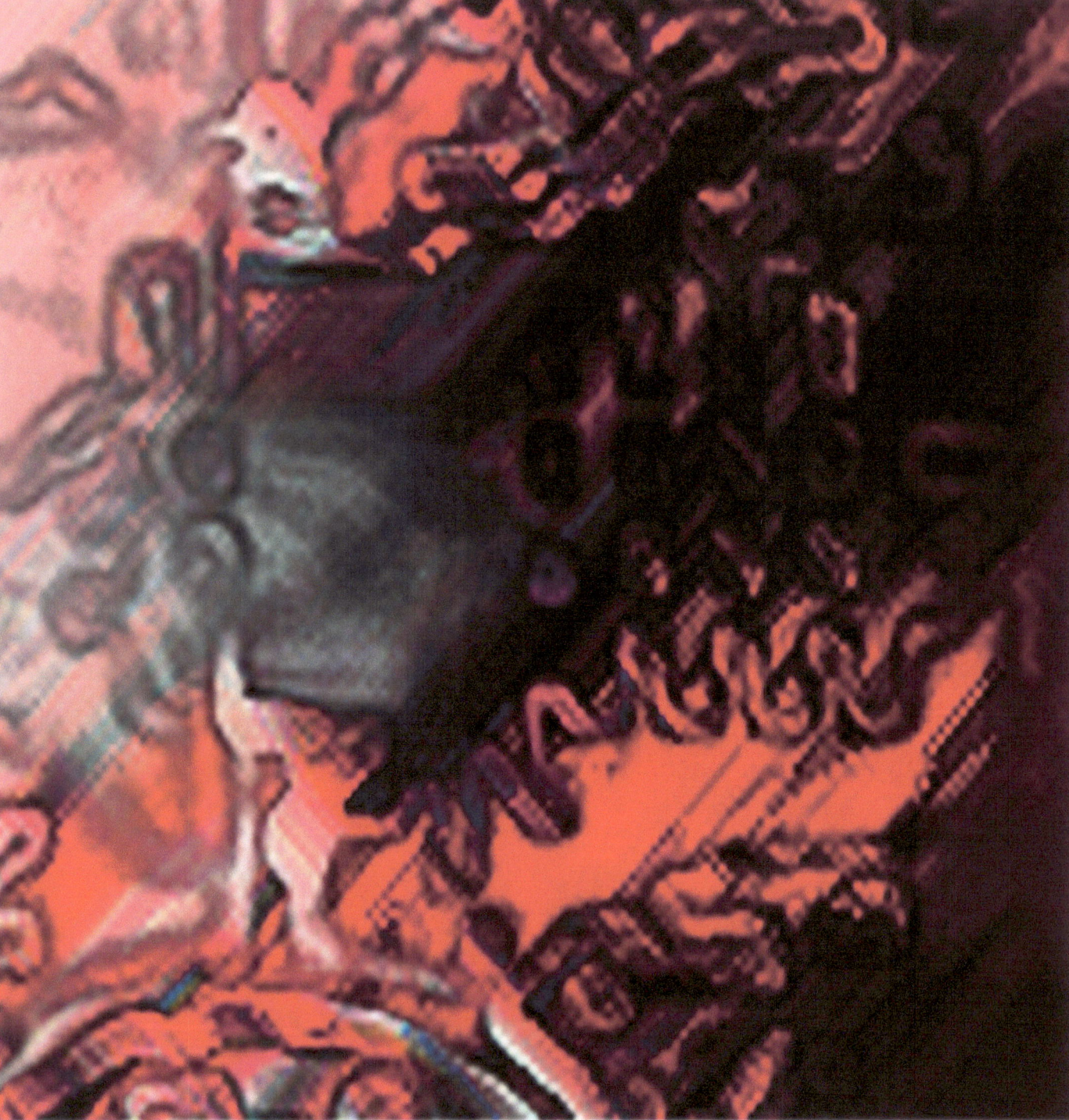

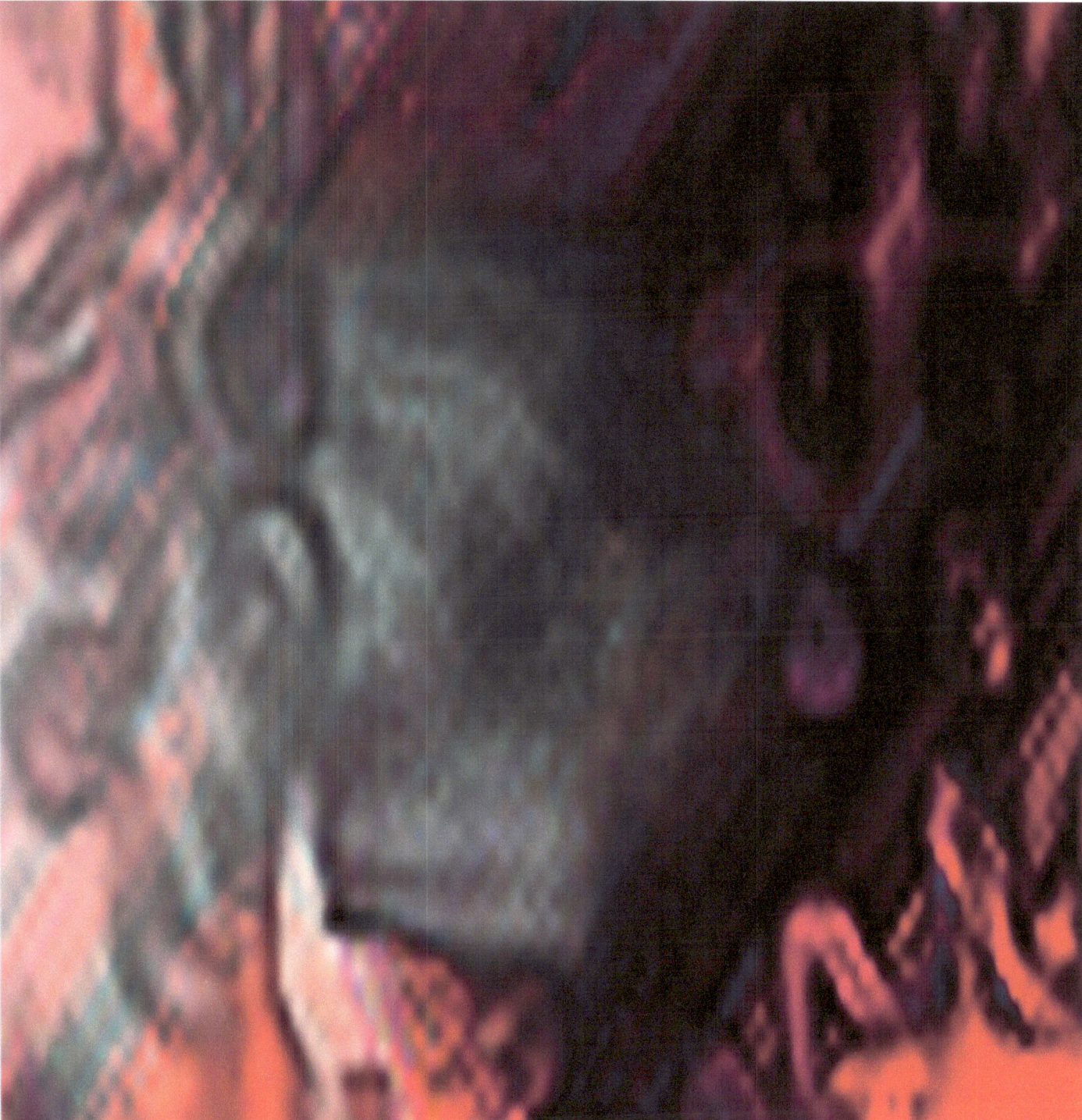

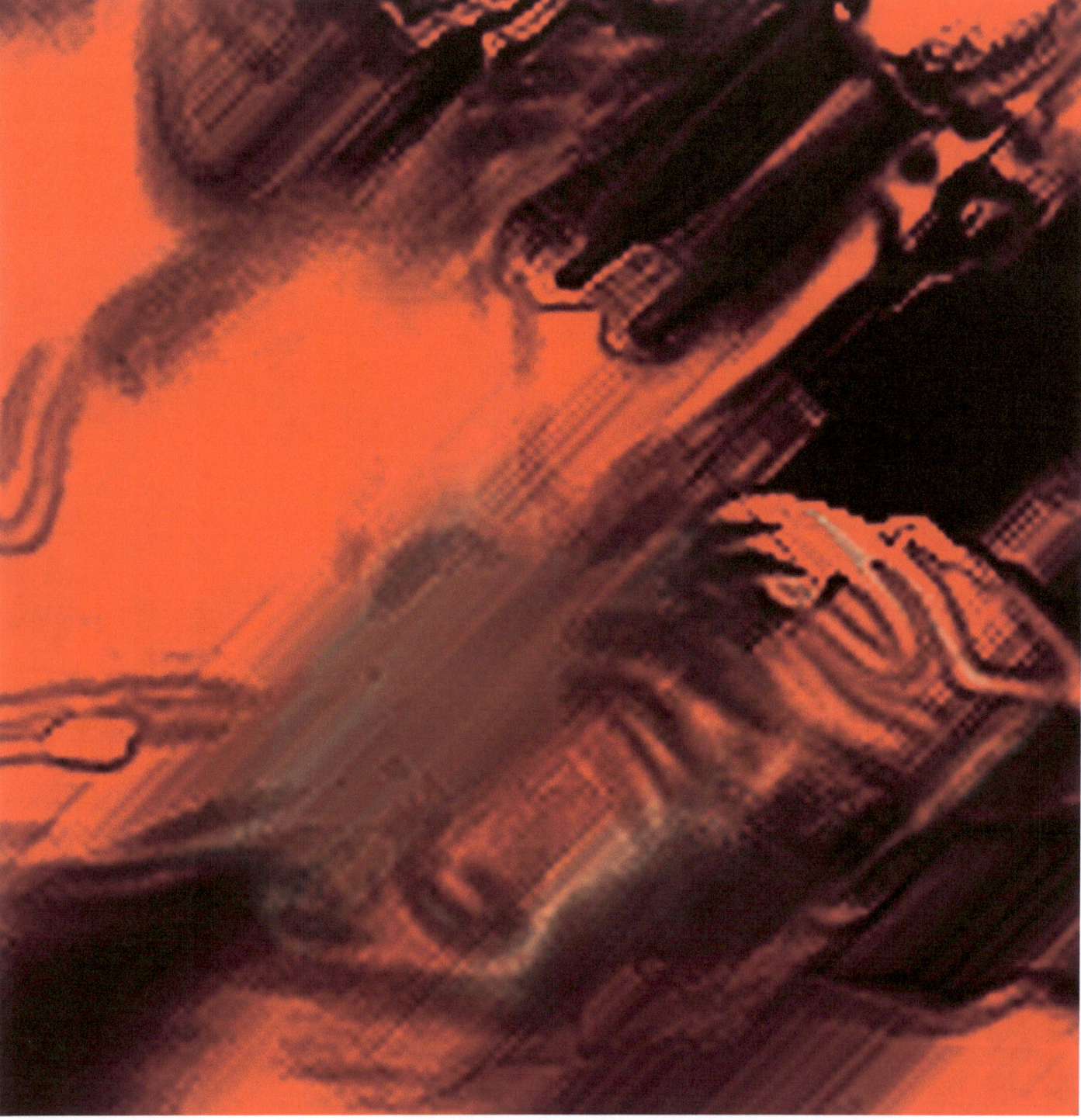

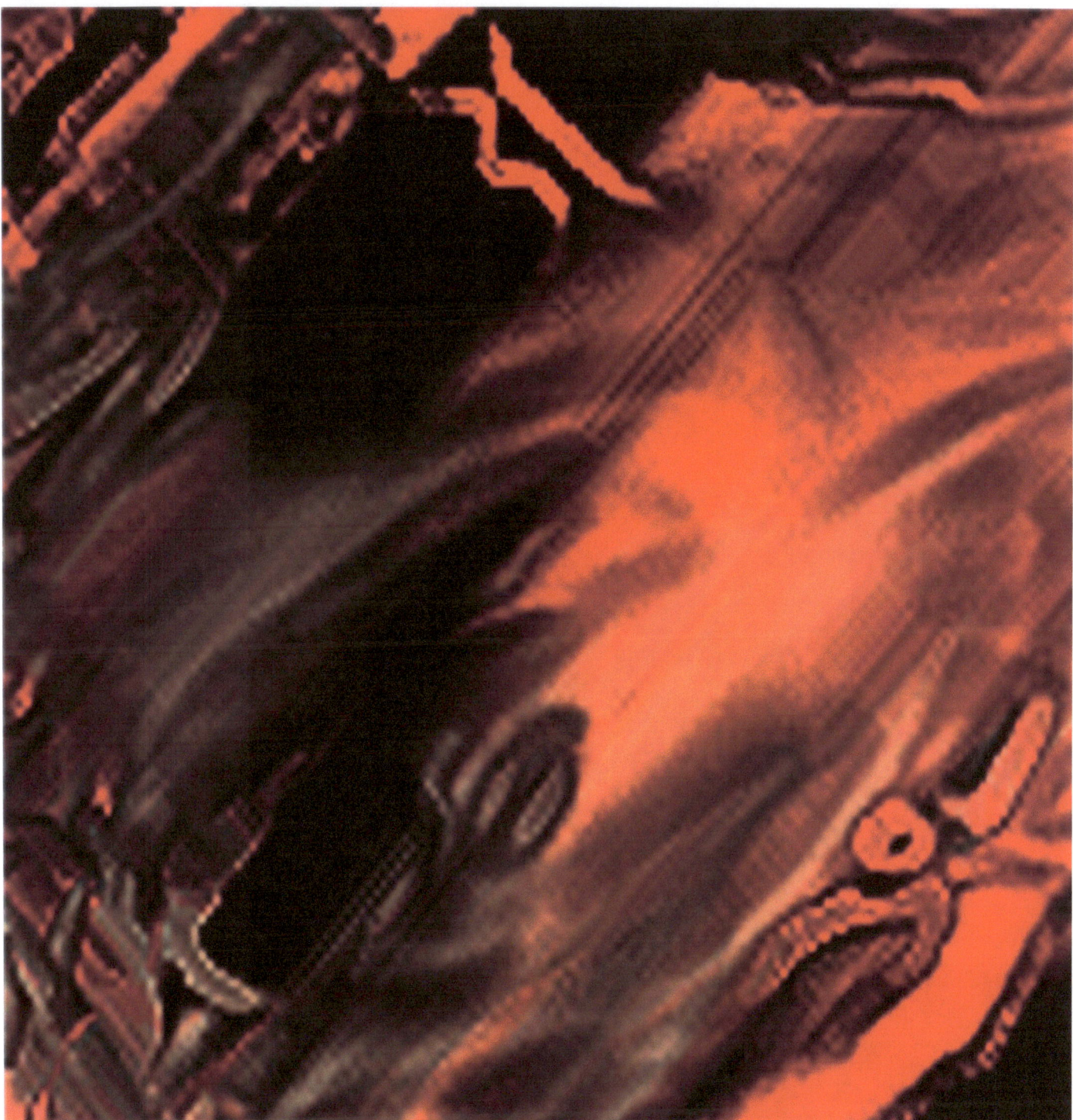

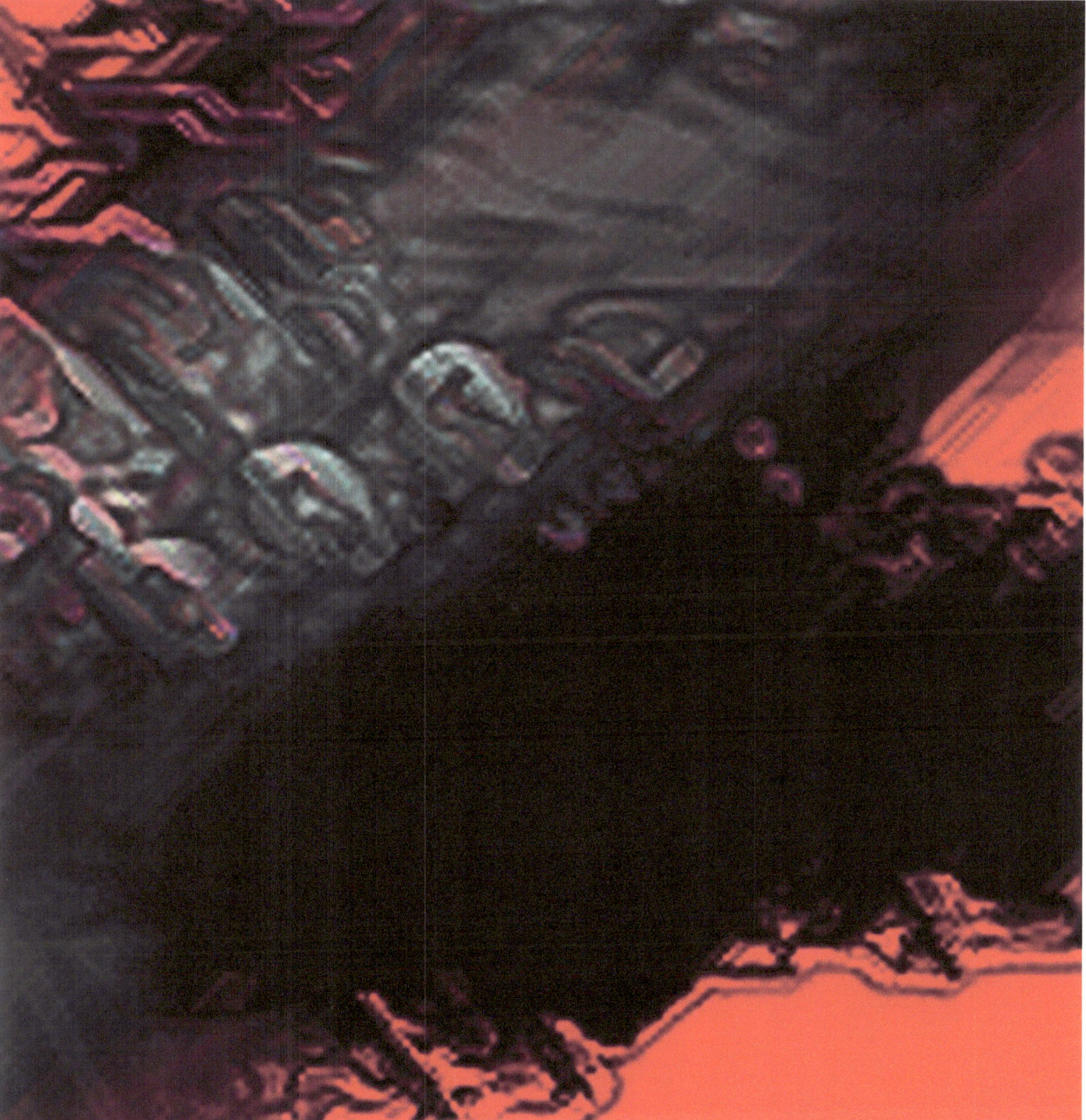

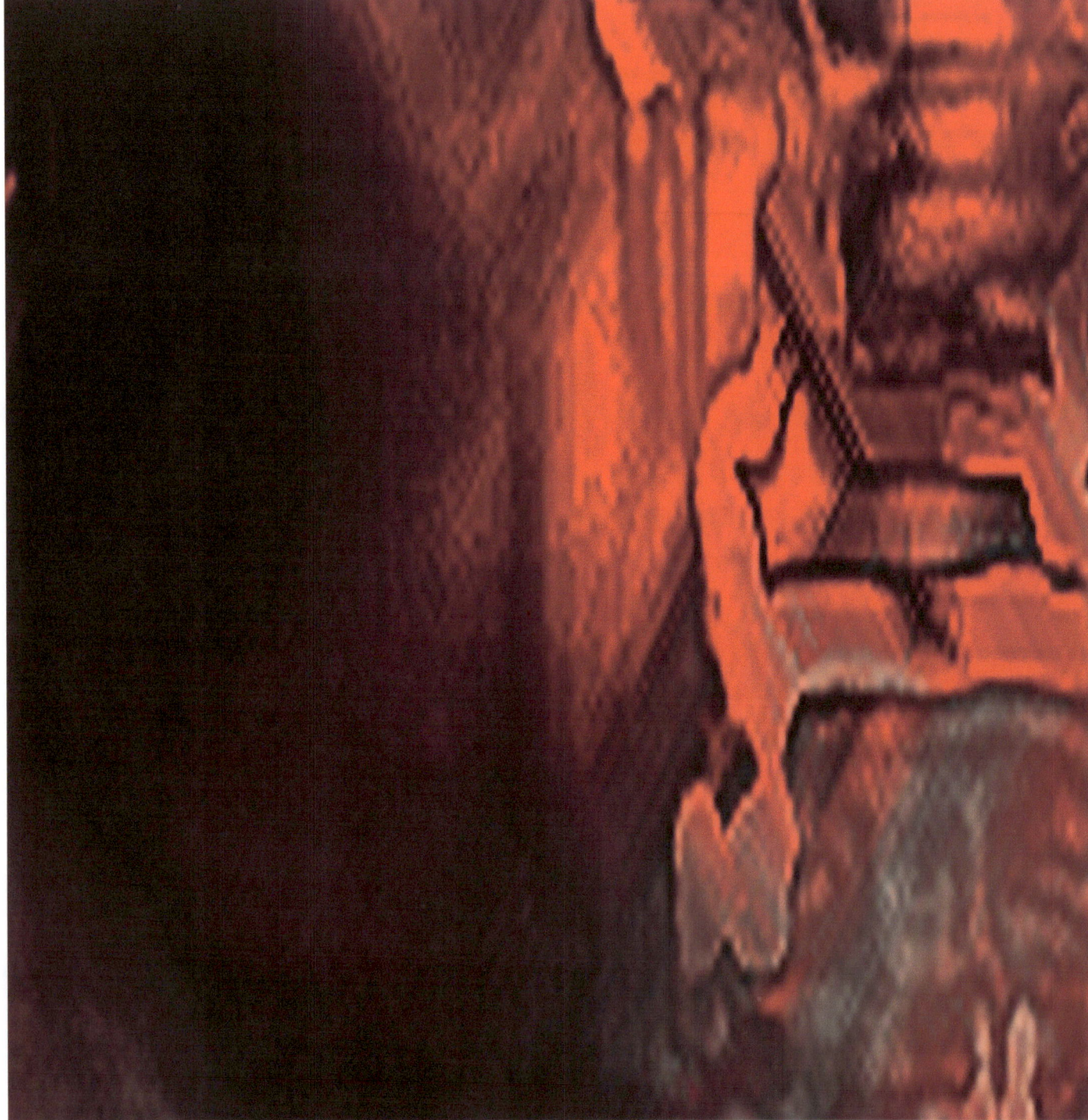

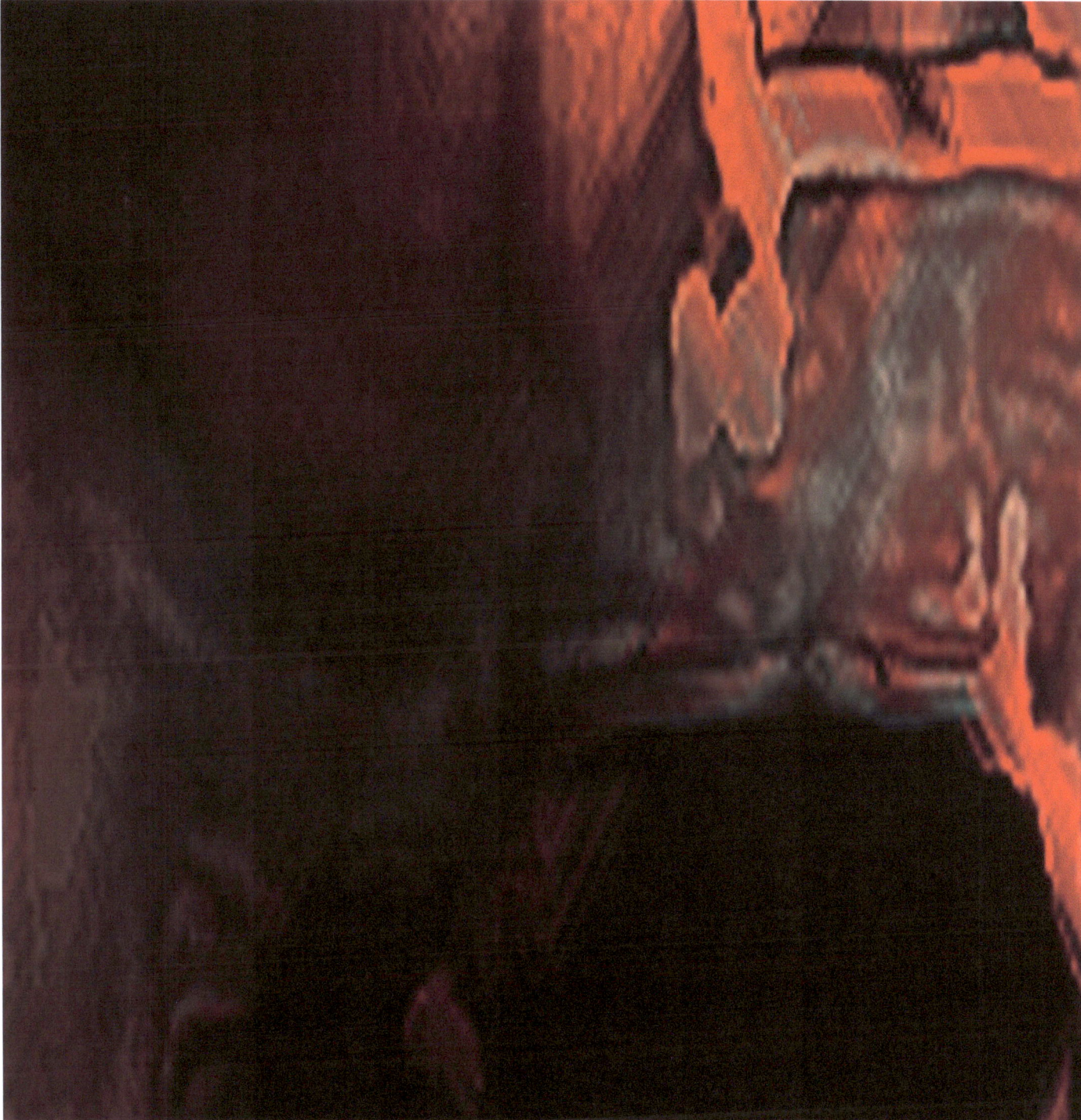

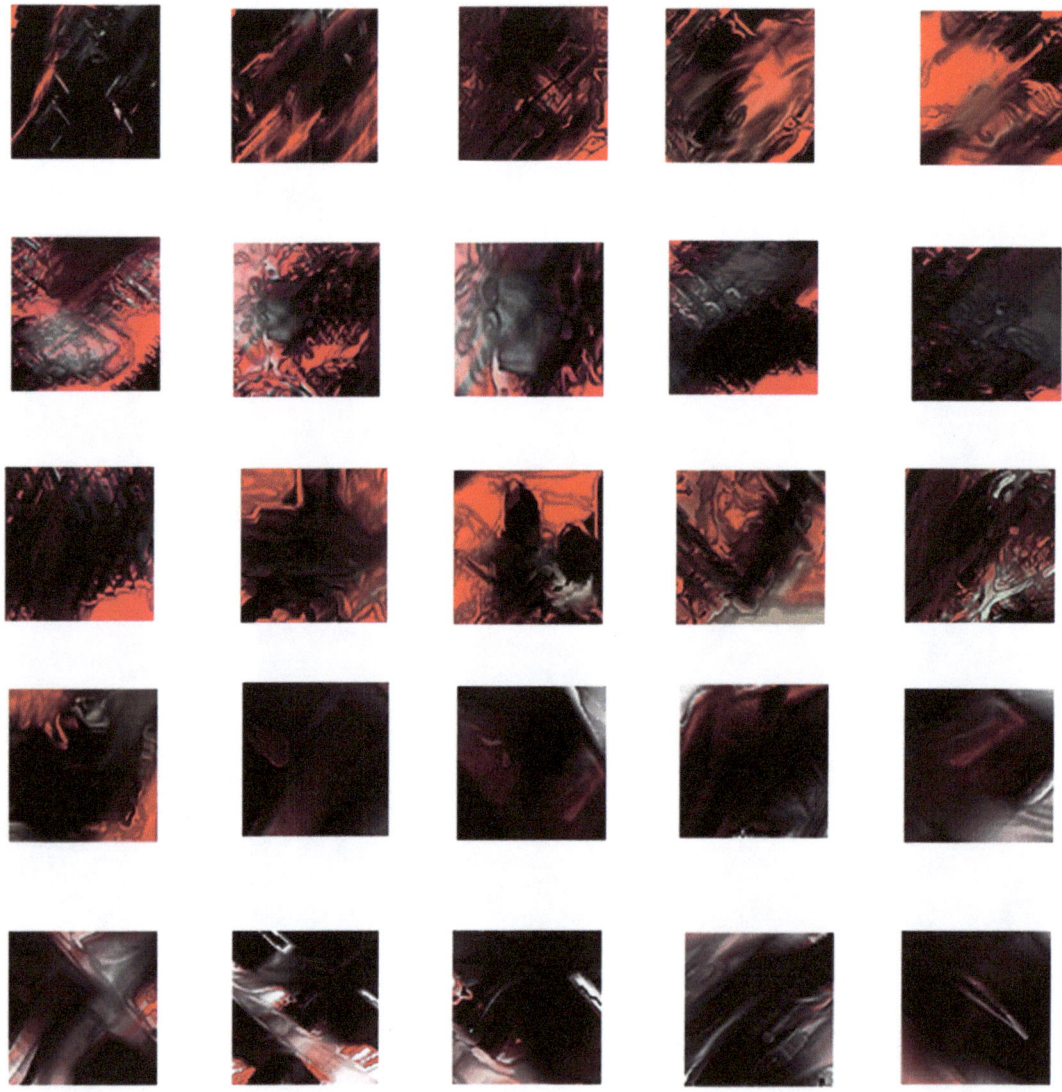

RED 2002

The first showing of images from Memories of Sand: Excerpts of Computer Thought Photography was in 2000 at the Tra Gallery, New York City.

Titled RED 25 images were printed with an ink jet printer on light sensitive photo paper. Each image was 12" by 12" mounted on 12" by 12" pieces of foam core board and hung against a white wall.

This is an image of the arrangement I decided to display for that show.

Teer received a BFA in painting at Rhode Island College and studied computer design at The Fashion Institute of Technology in New York. He currently lives and creates in Staten island New York.

T.M.

www.ingramcontent.com/pod-product-compliance
Lightning Source LLC
Chambersburg PA
CBHW051048180526
45172CB00002B/557